What They're Saying About *Unleash the Artist Within*

"Brilliant insights have one thing in common – they make you marvel, 'Why haven't I thought of this?' Don't rack your brain any further. *Unleash the Artist Within* will spare you the deep-sea dive into your subconscious. Bob Baker presents all the wisdom you ever sought in a clear, easy-to-use style, leaving you with a unique 'nothing can stop me now' feeling."
-Christine Spindler, author of the Inspector Terry Mysteries, www.christinespindler.com

"*Unleash the Artist Within* is an outstanding book! Sure to get your creative juices flowing. Bob Baker has years of knowledge, great tips and an ability to inspire."
-Marc Gunn, musician, the Brobdingnagian Bards, www.marcgunn.com

"You'll find one amazing idea after another in this inspiring guide for creative people of all kinds. Want to increase sales and boost your name recognition? *Unleash the Artist Within* is a must!" **-Kim Gaona**, Kim's Reviews, www.kimgaona.com

"*Unleash the Artist Within* takes all of the insights, tips and tools of the smart marketers, sales people and retailers of the world and shoehorns them into one book. Almost every topic results in an 'A-ha' moment. All together, readers should be slapping a big, fat, juicy kiss right on Bob's cheek."
-Jeff Zbar, 2001 SBA Small Business Journalist of the Year, author of *Home Office Know-How*, www.goinsoho.com

"Are you a creative person ready to ditch your day job? Bob Baker's *Unleash the Artist Within* offers solid strategies to help you towards your goal. Whether you want to tap into your creativity or market yourself to a larger audience, this book has something to offer. Don't wait another day to get your dreams into gear!" **-Carla Hall**, singer/songwriter and author of *The Musicians DIY Guide to the Music Biz*, www.carlahall.com

D0911241

This Book Is Just One Part of an Ongoing Creative Journey

I hope that your decision to read this book marks the beginning of a long-term relationship between us. I'm confident that the principles and suggestions in this book will inspire you and help boost your mental outlook and self-promotion efforts to new levels.

To make sure these ideas stick, I encourage you to visit my web site at **PromoteYourCreativity.com**. There you'll find free articles and countless resources to help you get more exposure, attract more fans and sell more of your creative product or service.

While you're at the site, be sure to get your free subscription to my e-mail newsletter, called *Quick Tips for Creative People*. Once or twice a month, the e-zine delivers a dose of motivation and marketing tips for writers, artists, performers and anyone pursuing a creative passion.

I'd love to hear from you, especially if you have a career tip or strategy that I could share with the thousands of creative people who subscribe to my e-zine.

Do yourself a favor and pay a visit to **PromoteYourCreativity.com** the next time you're online. You'll be glad you did.

–Bob Baker

Unleash the Artist Within

Four Weeks to Transforming Your Creative Talents Into More Recognition, More Profit and More Fun

Bob Baker

DORIAN,
TO YOUR
CREATIVE
SUCCESS!

[signature: Bob Baker]

MAY '04

ISBN: 0-9714838-1-7

Table of Contents

Welcome to Your New Creative Life

You are about to embark on an invigorating four-week journey. For the next 28 days you will immerse yourself in one simple lesson every day that will help you focus your energies on making the most of your creative talents.

Whether you are pursuing an interest in music, art, writing, acting, photography, crafts or any other creative field, what you do during the next four weeks will create the foundation upon which your creative future will be built.

I wrote this book because I was frustrated by the traditional view of people who aspire to pursue life and work in the arts. I often asked myself: What is it about creative career paths that cause so many people to look upon them with such disrespect; even disdain?

"You go ahead and get those artistic urges out of your system," parents, friends and complete strangers say. "Once you wise up, you can go out and get yourself a real job."

Why must musicians, artists, writers and actors endure this nonsense? Medical students have to struggle

for years before getting established and cashing in. I've known a couple of lawyers who didn't have the drive to effectively build their practices, and they ended up disheartened and frustrated. Yet you never hear phrases such as "starving lawyer" or "tortured doctor." No, those terms are reserved for creative types – the "artistic" ones with the unrealistic, pie-in-the-sky dreams.

Let's put an end to this craziness here and now!

I'm not implying the creative road is paved with gold. But it holds as much potential as you're willing to give it. The truth is, in every artistic field there are successful people making lots of money and people who are struggling – just as there are in all fields.

Make no mistake. You can get recognition, earn money and feel joyful along just about any creative path. You just have to put a few basic principles into action on a regular basis to be successful.

This book is designed to give you some of those guiding principles. Within these pages you'll find three types of ideas:

- Insights that inspire you and motivate you to keep moving toward your creative goals

- Lots of low-cost marketing ideas to help you promote and sell your talents more effectively

- Tips on using your brain to have fun and generate even more creative output

Don't get caught up in the starving artist mentality. Take the ideas in this book and use them to create your own new definition of what it means to be a creative success.

Who Is This Book For?

Of course, this book was written for artists, writers, musicians and other creative people. But people who fit those descriptions fall into different categories of accomplishment. It's important to know these categories and where you fit in. *Unleash the Artist Within* was written for people who fall into any one of the following three types of artistic pursuit:

- Full-time with an interest in enjoying a more prosperous career

- Part-time and working toward full-time activity

- Part-time with an interest in turning a hobby into a more rewarding sideline endeavor

If you already enjoy a full-time devotion to your craft, this book will help you recharge your enthusiasm and boost your notoriety and income. If you're currently working another job and aspire to pursue your talent full time, you'll find dozens of tips to help you make the transition faster.

It's important to note that not everyone has to be a full-time, self-employed artist to be successful. Many creative people make a conscious decision to keep their art-related endeavors part time. By doing so, that doesn't mean artists have to resign themselves to obscurity just because they don't have full-time goals. It is possible to get exposure and make extra money from purposeful sideline efforts. This book will help you accomplish that, as well.

The bulk of *Unleash the Artist Within* is comprised of 28 lessons that will show you how to:

- Work from the trenches with little or no money

- Obliterate the "starving artist" mentality

- Build a customer base one fan at a time

- Use often-overlooked techniques to give your craft wider exposure

- Use each small success as a stepping stone to a bigger and more significant success story

Throughout this four-week course, I'll poke and prod you to be different, to expand your thinking, to focus your goals and actions – in essence, to become a supercharged creative being.

Each daily lesson comes with a commitment statement at the end – one or two sentences that summarize the core idea of the day. Use these statements as affirmations to help firmly implant each day's primary message.

I also ask you to do some serious soul searching and follow up your daily reading with some journal writing and a specific Action Step. I challenge you to expand your world of ideas, but it is also my goal to motivate you to transform these lessons into the very real world of your creative life. In other words, don't just think about these ideas. Act on them!

Also, buy a cheap spiral notebook or invest in a colorful, stylish journal – it doesn't matter, as long as you have some way to grab a pen and record your thoughts, ideas and actions.

Experts say that it takes repeating a new activity at least 21 days in a row before it becomes a new habit. That's the underlying premise of the 28 daily lessons – getting you to think about and act on your creative goals every day.

Only through this consistent application of ideas will you develop new, more empowering patterns in your life. It is my sincere desire that these effective habits move you light years closer to your creative dreams.

The final section of the book, called "Ignite Your Creative Passion," features a collection of articles and special reports filled with ideas and tips that will further inspire you to make the most of your talents. This section will give you additional tools to help you promote and sell your talents, open up your creative energies and more.

Welcome to your new creative life. Happy reading, thinking and doing!

–Bob Baker

Section One

Unleash the Artist Within 28-Day Workshop

Day 1

The Mental Trick That Propels Your Creative Success

Moneymaking success has as much to do with your frame of mind as it does your luck or family tree. Remember this first important rule of prosperity: *You are what you think*. In the same way that what you eat often dictates what your body looks like and how it functions, your thoughts and attitudes directly influence what you accomplish in life and how you carry yourself.

How many times have you heard the phrase "starving artist"? Or how often have you heard one of your peers say, "I'm never going to make any money with my art. Why bother?" It should be no surprise that the people who say (and therefore think) these things the most are among the poorest individuals you know.

Lesson: If you tell yourself something often enough, it becomes a self-fulfilling prophecy.

The best way to avoid the negative-thinking trap is to program yourself for success. Stop thinking and uttering thoughts of limitation and deficiency. Start getting your mind attuned to thoughts of boundless opportunities and abundance – then watch what sort of rewards come your way.

Many of us are so used to thinking in negative terms, it's difficult to shift into positive gear and stay there. A great mental technique to reprogram your thoughts is the use of daily affirmations.

Don't worry – I'm not going to ask you to look in the mirror and tell yourself, "I'm good enough, I'm smart enough, and doggone it, people like me." But I am going to insist that you seriously consider using affirmations (if you're not already doing it).

Affirmations are a crucial component to making money with your creativity. They remind you of your goals and keep you focused on achieving them. In his excellent book *Do It*, author Peter McWilliams writes, "To affirm is to make firm. An affirmation is a statement of truth you make firm by repetition."

To get the most out of them, affirmations should be written as specific statements that spell out what you want to obtain and when you want to obtain it. They should also be read every day and worded in the present tense.

You should avoid writing generic statements like "I will be a successful photographer some day." This is not an effective affirmation. It's too bland and vague. On the other hand, "I make $3,000 a month by December of this year doing fashion photography for regional magazines" is a much more specific, results-oriented affirmation.

"Affirmations force you to challenge old, self-limiting thoughts and replace them with more desirable words and images," writes Barbara Winter in her book, *Making a Living Without a Job*. "More important, affirmations get

you to think about yourself and your life in new ways – ways that expand your power and possibilities."

Along with these personal statements, use the art of visualization. While reading or reciting your chosen affirmation, mentally picture yourself doing and achieving what you want. Ask yourself, "How would attaining this goal make me feel? What would it look, sound, smell and taste like?"

Immerse yourself in the concept of what you want to accomplish. Imagine the emotion you'd experience if it were really happening, complete with the sensations you'd get through all five of your senses. Then over the days, weeks and months that follow, enjoy watching your image of success materialize before your eyes.

Commitment statement:

"I am what I think! Therefore, I no longer think and utter thoughts of limitation and deficiency. I now fill my mind with thoughts of boundless possibilities and abundance. I can and will succeed with my creative talents."

Today's Action Step

Craft your own personal affirmation – what I call a Big Picture Affirmation. It's okay to use the 28 commitment statements at the end of each daily lesson as affirmations, but it will be more beneficial for you to have an overall affirmation that you refer to on a regular basis.

Don't rush through this process. Try out several different versions and ways of expressing your creative

goals. Make your affirmation simple, but make it bold and specific.

Then make copies of your Big Picture Affirmation and post them in strategic locations: the bathroom mirror, the bedroom nightstand, the dashboard of your car – places where you'll see your affirmation often and be reminded of it regularly.

Really do this – don't just read about it. You're serious about the investment you made in this book, right? I thought so.

Now get going!

Day 2

The Art of Self-Confidence: Your Unstoppable Force

Eleanor Roosevelt has often been quoted as saying, "You must do the thing you think you cannot do." She was right. As exciting as being successful with your talents is, it's also scary. Do you really have what it takes? What if you fail? Or what if you succeed and thousands of people suddenly have grand expectations of you? It's no sin to have doubts and to fear the unknown. But doubts and fears shouldn't consume you and make your progress more difficult.

Especially during those times when things aren't going well or people are critical (and you will encounter resistance), your confidence in your abilities will carry you through. Without confidence, you'll face an uphill battle.

For five years, I served as the director of an annual music conference in St. Louis. As part of the workshop portion of the event, we offered one-on-one sessions that allowed attendees to meet face to face with some of the music industry panelists.

Later, some of the panelists told me they were surprised that so many aspiring musicians seemed to be looking for a confidence booster. A lot of the attendees

asked questions such as "Do you think my project has a real chance of making it?" or "Is this really worth pursuing?"

While these are understandable questions inspired by normal feelings of self-doubt, make no mistake about it: You need to find a way to develop a strong, unwavering belief that what you are pursuing is worthwhile and right for you. If you can't, then you'd better reconsider your choices and find another path that will give you a feeling of purpose and destiny.

"The thing always happens that you really believe in," said Frank Lloyd Wright, "and belief in the thing makes it happen."

Michael Laskow founded and operates TAXI, a company described as "the independent A&R vehicle." TAXI is a service that connects aspiring songwriters and bands with record labels and music publishers.

Michael once described his attitude when starting his company. "When I first introduced the concept, everybody told me, 'That's already been tried before. It'll never work.' But I believed it would work," he explained.

"So for a year and a half I put in 18-hour days getting the word out and building the business. And it's become a tremendous success. Now the same record label people who ridiculed me in the beginning are calling to get new songs through TAXI."

Lesson: Find a creative niche that will excite you and hold your interest. Once you're confident it's right for you, know that you will be successful at it – as long as you're willing to pour your energies into it.

"You're always believing ahead of your evidence," poet Robert Frost once remarked. "What was the evidence that I could write a poem? I just believed it. The most creative thing in us is to believe."

Develop a sense of expectancy when pursuing your creative and money goals. When you expect to win, more often than not you will.

Commitment statement:

"I believe, to the core, that my chosen artistic niche is the ideal one for me. I am filled with a sense of confident expectancy as I head toward my creative goals."

Today's Action Step

Think of a skill or activity in which you excel and feel very confident about. Now get out your journal and write down all of the reasons why you feel so strongly about your abilities in this area. Include your past experiences with it, the thrill that it gives you and the way it makes you feel about yourself when you accomplish the activity.

Now consider something you've always been interested in but are fearful of trying. Write down the reasons you feel you have a lack of confidence in this area. Examine your fears and insecurities.

Compare your responses in each area. Is the difference a lack of true ability or a lack of direct experience? Do you suffer from a fear of failure or a fear

of success? Is your lack of confidence based on real-world truths or on the uncertain perceptions in your mind?

Key question: Would your confidence level improve if you immersed yourself in your creative pursuit while realizing that fear is a natural part of growth?

Write down your answers to these questions and find your inner source of self-confidence – the reasons why you deserve to feel confident about your worthy creative goals.

You're doing a great job so far. Keep it up.

The Best Way to Handle a Lack of Time or Money

Yes, the arts-related industries are fun and appealing, but to succeed in them, you must also put forth a considerable effort. And that effort often requires two of your most precious resources: your limited time and your scarce cash flow.

If you have substantial financial reserves or an eager investor, that's one thing (and a whole other can of worms if you're unable to manage your time and someone else's money). But what if you have no savings to invest or money sources? You give up and go to work as a telemarketer, right?

Hardly.

Teddy Roosevelt was credited with this inspiring quote: "Do what you can, with what you have, right where you are." Those are some of my favorite words of wisdom. In fact, you would do yourself a favor to print them in large letters and strategically place them in your bedroom so they're the first words that greet you each morning (along with your Big Picture Affirmation, of course).

Personal example: Several years ago, I had an idea to produce a series of spoken-word instructional audiotapes covering various aspects of succeeding in the music business. Nobody was putting out quality music business how-to information in the audio format, and I was very excited by the prospect. So I worked hard and put together a script for the first 60-minute cassette.

Unfortunately, by the time I was ready to go into the studio and record, the profit margins with the music magazine I published at the time were in a temporary lull. The funds weren't there to record and package the product.

Was it time to put the project on hold till the money became available? Not a chance.

First, I offered free ad space in my magazine to a local recording company in exchange for free studio time. Then I used the same barter technique with some friends who ran a cassette duplication business, trading display ads for their service.

At this point I'd spent very little to get my first batch of tapes produced. But packaging the product was another animal. The tape already sounded good, but it also had to look professional to make a good impression as the first volume in the new series.

But the money wasn't there to cover this major expense. Still, there had to be a way. I made a call to a musician acquaintance who was a partner in a company that packaged audiotape programs. I sent him a copy of the tape and asked for his feedback. Many weeks passed before he called ... saying he loved it.

We set up a meeting, during which I asked him if he loved the tape enough to co-produce the project and finance it on the front end, with his reimbursement (and profit) coming as the tapes starting selling. We worked out an agreement and before long I had my first audiocassette program on the market.

The only reason I dragged you through this story was to impress upon you the importance of not letting a lack of money stop you from getting things done. Before throwing in the towel, brainstorm on your other options:

- Alliances you can form

- Credit terms you can negotiate

- Other things you can offer suppliers besides money

- Any other creative solutions you can discover

The same can be said for a lack of time. When I signed the contract for my book, *Branding Yourself Online*, I wasn't sure how I was going to pull off writing more than 100,000 words in five or six months – especially since I was working a full-time job and spending half of my time with my four-year-old daughter.

It was tough, but I dug in and took on one sentence, one paragraph, one section and one chapter at a time until it was completed. Holding the finished product in my hands (not to mention receiving many notes of praise) months later made all the effort worth it.

There are ways to work around shortages of time and money – if only you let your passion drive you to creative solutions.

Commitment statement:

"When time and money are needed, I move forward with the confidence that I can find a way to get things done – with what I have, right where I am."

Today's Action Step

Turn to the next blank page in your journal. At the top write down a project or marketing idea you want to pursue but haven't because of a lack of time or money. Now clear your mind and get ready to think outside of your usual mental patterns. Imagine you are entering a world where fear, self-doubt and frustration are temporarily put on hold.

Next, jot down every solution that comes to mind. No matter how ridiculous or improbable they may seem, write them down and answer these questions:

- What other paths could you take to reaching this goal?

- Consider the most expensive aspect of it and brainstorm ways to accomplish the same thing for less money?

- Who could you combine your efforts with in order to share the costs?

- How could you rearrange your current schedule to make more time for the project?

- Is there someone you could ask to help out and share the workload?

Once you've finished this brainstorming session, go over your list of solutions and highlight the top candidates you want to pursue. You'll quickly find that a lot of the rigid obstacles you took for granted are a lot more flexible and interchangeable than you once thought.

Day 4

Don't Buy Into the Artistic Integrity Myth

The first thing that comes to mind with this topic is the time I did a book signing at a music conference in Austin, Texas. I was there to promote my first book, called *101 Ways to Make Money in the Music Business*. (By the way, doing a book signing doesn't necessarily mean that people line up, eager to get your autograph. For a new author, it means standing there as people pass by asking, "Who's that guy?")

Out of nowhere, this fellow walked up, looked at the money-related reference in the title and said, "Yeah, right. That's what it's all about." Then he stomped off in a huff.

Somewhere along the line, this poor, misdirected soul latched onto the notion that money and music have no place together – that if you strive for financial reward, you're somehow tainted as an artist. The sad thing is, he's not the only one who thinks that way. Naysayers exist in all genres of the creative world.

Here's another example of the starving artist mindset in action: Since 1995, I've been active in marketing my books, tapes and services on the Internet. Dozens of web sites carry articles I've written over the years. Every

article ends with a short blurb that mentions my books and how to subscribe to my free e-mail newsletters.

Sounds innocent enough, right? But you wouldn't believe some of the hate e-mail I receive from people spouting off about me pedaling "snake oil" and "preying on people's dreams." They feel that any kind of financial ambition is a poison to someone's artistic integrity.

Sorry, but these people need a swift kick in the attitude department. When you encounter people who embrace these same shortsighted myths (and you undoubtedly will), you must accept these people as the misguided … um, *art lovers* that they are.

It's one thing to lust for money, use underhanded tactics to get it and hurt people in the process. It's quite another to realize you have an insatiable desire to pursue a creative longing and – *gasp!* – want to make a living and pay your bills while doing it.

Let's get clear on another point: There's nothing wrong with getting involved with an arts-related activity and not caring whether or not you get paid for it. In fact, if you can't pursue your chosen field and be happy without getting money, you're probably in the wrong profession to begin with. Yes, you should seek out a line of creative work that you'd continue to do with or without the cash. That's when you know you've found your true calling.

But when you take the next logical step and strive to develop a profitable business out of your passion, there's nothing wrong with that – despite what the pontificating purists proclaim – especially when the product or service you provide enriches and improves people's lives. And,

whether you're a recording artist, craftsperson, art director or poet, you will have to deliver that enrichment to your customers and fans if you are to succeed.

I view selling my artistic skills as an uneven exchange. I believe the value of what I have to offer is worth more than the money my customers have to part with to purchase one of my products or services (whether it's a book I wrote, a music CD my band produced or a piece of artwork I created). I encourage you to have the same confidence in the worthiness of your talents.

So if you have any guilt about actively seeking a steady cash flow from your talents, you'd better adjust that attitude quickly. Why should you continue to wait tables (or whatever else you do for a paycheck) and take time away from your real interests? Is it really necessary to be a poor, tortured artist to be respected? I don't think so.

Do yourself a favor and steer clear of irrational thoughts (and people) and commit to a process that will allow you to partake in the things you love doing – while earning the income you deserve.

Commitment statement:

"My pursuit of a steady income has nothing to do with greed or the erosion of my artistic integrity. It's all part of the natural human process of bettering myself. I realize that I have the most integrity when I use my talents to provide real value to the people who are my fans and customers ... and I'm not afraid to be amply compensated for delivered the creative goods."

Today's Action Step

Yes, it's time to grab your journal and write down more thoughts and ideas. First, I'd like you to imagine that you've reached the point in your life where you're bringing in a sufficient income from your ideal creative endeavor. Now list the benefits you'd experience by being in that position.

How relaxed would you be if you didn't have to worry about how the rent would get paid every month? How satisfied would you be if you could focus full-time on your creative activities? What specific positive results would come about if you did indeed make good money with your talents? Take several minutes to visualize these things and write down your responses.

Now switch gears and think about how you'd feel if you didn't generate much income with your creativity. Is this your current situation? Are you required to work at a job from which you don't get much personal satisfaction? How many people are missing out on enjoying your talents because you don't have the time to promote yourself properly?

Does your current schedule allow you to spend an adequate amount of time engaged in your craft (whether it's singing, acting, painting or writing)? What are the drawbacks of not making enough money from your creative skills? Spend another several minutes exploring your frustrations in this area.

When you're finished writing, compare the two lists. Allow the prospect of a better, more profitable life to be the carrot, while the frustration you're currently feeling

acts as the stick. Let pain and pleasure work together to propel you toward your goals.

You're making great progress. Stay at it.

Day 5

Obliterate Your Negative Associations with Money

Do you have negative mental associations when it comes to money? Let me pose another question: Have you ever uttered phrases such as "Money isn't everything," "I can't afford that," "Money doesn't grow on trees" or "Watch your wallet"?

Whether you're aware of them or not, you have strong beliefs concerning the green stuff. And while they may seem harmless, any cynical associations you may have are unconsciously slowing down your pursuit of artistic success. But don't worry, there's still hope for you.

You must realize that the negative attitudes you have toward money (and other things) come from only one source: your conscious decision to buy into them. In other words, you carry around countless associations to people and events – both positive and negative – based largely on your previous reactions to similar circumstances in your life. These repeated reactions shape your outlook.

Want some examples? How about associations such as: Agents can't be trusted. Critics are out to get me. Lead singers are premadonnas (well, that one may be true ...

just kidding). Or how about these associations: Winning an Oscar would give me power, or a best-selling novel would make me important.

Hello! Here's a wake-up call for you. None of these associations – or generalities about the world – are really true. But you still believe them wholeheartedly because of the mental patterns you've created in your life.

As an example, sometime early in your career, maybe a director backed out of his promise to cast you in the lead role of a play. In your mind, you may have said, "Boy, this theatre business is really unfair." Then you asked yourself, "Will everyone try to screw me over like this?"

Then somewhere down the line, after hearing other people echo similar negative sentiments, a local theatre critic wrote a less-than-flattering review of one of your performances. While out at your favorite coffee house, you started griping, "See, what did I tell you? Theatre in this city sucks!" And the pattern continued.

Every time someone goofed up or wronged you, it reinforced the associations you created. And now you can't even think about theatre without going berserk!

Of course, you should be on guard when it comes to people who have less than honorable intentions, but don't you see how ongoing negative associations can eventually work against you? Why buy into these destructive, limiting patterns when you could just as easily decide to create new patterns that create strength and inspire action?

The same thing goes for people who feel that an Oscar or best-selling novel will give them power and

importance. What kind of real power would they have with beliefs like that?

However, compare those shallow viewpoints to the guy who has chosen to believe that his power and importance come from his talents and the joy he delivers to his fans …

Okay, I'll give you a moment to wipe away the tears; I know that was a touching story. But think about it. What sort of associations have you made concerning money, and how are they keeping you from getting it?

For you, is money power? Is money the root of all evil? Does money corrupt you? Is money something you can only get by slaving away at a job you hate? Are you destined to always be a starving artist? If so, then just realize that you carry those associations because you have repeatedly made choices to do so.

The good news is that you can start right now – *today* – making new choices that will give you real power and control over money, instead of the other way around.

For instance, instead of thinking that money is something you have to fight and scrape to get, what if you believed "Money is something I deserve to earn in abundance."

Instead of feeling that having ample amounts of cash will corrupt you, why not believe "With a considerable amount of money, I can reward myself and share it with others."

Instead of thinking that making a living from your creative passion is an impossible, up-hill struggle, why

not believe "A steady flow of money is easily within my reach, if I only go for it."

What sort of person would you be if you truly held these beliefs about money and your ability to get it?

Commitment statement:

"I have no room in my life or in my thoughts for negative attitudes about money. Money is a positive force that I use to better myself and others. And there's nothing wrong with that."

Today's Action Step

Today's exercise will continue the rephrasing examples above. Make a list of the beliefs and clichés that you've been carrying around regarding money. Include the obvious, surface-level slogans that pop up as well as the deeper, subconscious attitudes you harbor.

Next, write out a new way to express each belief. Frame them in a positive, affirming manner – one that will obliterate the old, ingrained way of thinking with the new, empowering idea.

It's taken many years to develop your current set of money beliefs. They won't want to move out quickly on their own. But move out they must – in fact, they must be thrown out – if you are to fully embrace your newfound right to abundance.

Day 6

Are You Ready to Take Action Now?

A friend of mine, who I've been told is a promising writer, has been telling me for more than a year that he's ready to dive into that long-awaited music journalism career. But guess what? He is no closer to writing his first article today than he was a year ago.

Of course, if you ask him, he's got a handy list of good reasons his career is permanently stuck in Limbo. Like too many aspiring artists, he comes up with convenient reasons for not doing what he says he really wants to do, such as:

- He doesn't have the time to fully devote to writing now.

- He wants to get a new computer first.

- His muse hasn't paid him a visit lately.

- He could start writing now, but with the lousy job market these days, what's the use?

Sound familiar? Some people need all their ducks in a row, all the pieces of the puzzle in one place and all the stars aligned in a certain cosmic pattern before they'll even consider taking the first step toward a creative goal.

Here's a prime example from my own experience: Several years ago, I made a trip to Memphis. While there, I picked up one of the local newspapers.

In one publication I saw "News of the Weird," a column that reported strange but true news items from around the world. It was hilarious. The column ended with an address to contact the writer who compiled the stories. I had been publishing my music newspaper for a few years at the time, so I decided to write and see if I could carry the column in my paper.

However, I ended up doing nothing about it. I took no immediate action. And about six months later, "News of the Weird" began running in a competing paper in my hometown. To this day, it's one of the more popular features in that paper. By not acting, I missed the boat – and a great opportunity.

Don't take this same approach with your career. Making money with your talents is not something you'll eventually get around to some day. Carving that special (and profitable) place for yourself is something you can start working toward right now. Why wait? Every day that passes is full of missed opportunities if you choose to continue only daydreaming about the level of exposure and success you desire.

"One job finished is worth one hundred partially done," writes Russ Von Hoelscher in his book *How to Achieve Total Success*. "You can't be a winner if you don't get in the race, and you can't be a winner if you drop out of the race."

Let's get one thing straight: This book is not about getting rich quickly. You probably won't be making

$1,000 a day in your chosen vocation tomorrow. Chances are, you're not going to be a multi-million dollar film producer by next week if you're new to the field.

But you could start gathering information by making a phone call or sending an e-mail ... RIGHT NOW!

You could go to the public library and research your favorite moneymaking topic ... RIGHT NOW!

You could set up a meeting with an expert on your chosen topic or offer to do an internship for him or her ... RIGHT NOW!

Don't waste time. Even if you can't quit your day job just yet, at least start laying a foundation for when you can. And start doing it ... RIGHT NOW!

Commitment statement:

"To become successful and financially comfortable with my creativity, I must make a conscious decision to do so and then be willing to take the action necessary to make it happen. And I will begin taking that action ... RIGHT NOW!"

Today's Action Step

Now it's time to make the leap from thinking and writing to acting on your desires. Let's make this simple. Get out your journal and write down five simple things you could do this very moment to help you move closer to your creative goal. These actions shouldn't be earth shattering. I'm talking about uncomplicated, easily doable tasks. Write down five of these simple actions.

Now pick one item on the list and do it. Really do it. And do it now!

Don't keep reading and tell yourself you'll do this thing later. Get up and take action right now.

Go ahead, I'll wait here until you get back ...

...

...

...

...

...

...

...

Way to go! You did it!

Now pick up a pen and scratch a line through that item to indicate that you've accomplished it. Congratulations! You've just taken an important step toward boosting your creative career – which is exactly what it'll take to reach your goals.

Now choose two other actions from your list and do them sometime over the next 24 hours. When we meet again tomorrow, I'll ask you about them, so make sure you do them and scratch them off your list.

You're doing a great job. Keep it going.

Brainstorm Ways to Earn Extra Money and Gain Exposure

Here's where we get busy by getting you actively involved in the opportunity-finding process. You should already know that there are literally dozens upon dozens of satisfying and profitable niches you can pursue by offering your creative talents. But if you're unsure which one is right for you, you need to start doing some soul searching right now.

(If you already know where your calling lies, don't think you can breeze through today's lesson. This section will also help you discover new and better ways to promote and sell what you offer.)

The first thing I suggest you do is make notes in your journal every day – and not just when you do the Action Steps. You can do this at any time. As you ponder the message in each day's lesson, ideas will surely come to you throughout the day. Make certain to have your journal and a pen nearby to capture them all.

Writer Barbara Winter refers to her idea file as an Option Bank. "Just like the place where you store money, an Option Bank is a repository of good ideas, dreams and goals," she explains in her *Winning Ways* newsletter.

"And like an ordinary bank, the more you put in, the more you can draw out."

I highly recommend that you schedule regular brainstorming sessions with yourself for the sole purpose of adding to your Option Bank. There are a number of ways to accomplish this, but regardless of how you approach it, the important thing is to get your mind working while capturing all your ideas on paper.

One way is to just let the floodgates open. Start thinking of every possible way you could make more money or get more exposure with your creativity. Don't judge or censor anything at this stage. No idea is too crazy. Just let it rip and write it down.

Your notebook of ideas will fill up quickly. Many of your ideas may reflect concepts suggested in this book, but look beyond that. Start mixing and matching creative business niches and see what happens. You may come up with a completely new slant on an old idea. Try it.

After this initial brainstorming session, challenge yourself to come up with three new ideas every day for ten days in a row. This will shift your thoughts into what I call "opportunity mode," allowing your creative subconscious mind to get into the act. Once the idea-generation seed is planted, fresh concepts will start popping into your head when you least expect it.

Before you know it, you should have a hefty list of possible avenues to pursue. Now what? It's time to start whittling the list down to the ideal way (or ways) for you to make money, promote yourself or sell more.

You'll probably be tempted to get a quick start on one of your hot, new ideas. However, I suggest you let them

mentally simmer for a few days. (By the way, this is one of the only times I'll suggest you *not* act right now on something.)

After a few days, look over the list again with a fresh eye. How much do the ideas excite you now? I've found that my core beliefs and passions (music, writing, conveying useful information, humor) are things that have stood the test of time. While some interests come and go, the activities that really make you tick tend to stick with you for many years – even a lifetime.

The easiest way to get to the heart of your niche is to ask yourself specific questions – and then answer them honestly. Here are some good ones:

- Which of these things would I have the most fun doing?

- Which ones would I have the most drive and desire to work at every day?

- Will I be able to grow into that career path and enjoy the process?

There's a gold mine between your ears. Use your brain more often to help you find the solutions and the path to your bright creative future.

Commitment statement:

"My mind is my most valuable tool in striving for creative success. The more I use it to brainstorm ways to succeed, the better off I am. And once I find the right profitable niche for me, I'll continue to use my mind to create more value in what I do – and, thereby, experience even greater success."

Today's Action Step

First off, I need to make sure you've followed through on the other two tasks you wrote down from yesterday's Action Step. You do remember, right? I asked you to write down two things you could take action on within 24 hours. Well, your time is up. Have you completed them and scratched them off your list?

If so, congratulations for taking initiative and proving that you're in this for real.

If you haven't done them, drop everything and do them now. I'll still be here when you come back.

Today's Action Step involves simply following through on the brainstorming exercises described in today's lesson. True, it may take a few days or more to generation a significant number of ideas this way. And today is the best day to get started on it.

Congratulations on making it to the end of this first week of the *Unleash the Artist Within* workshop.

Keep in mind, though, that these ideas and new ways of approaching your passion won't take root with a single exposure to them. You must be reintroduced to them again and again, until they become a part of your being. That's why it's so important for you to apply these principles on a daily basis.

See you tomorrow.

Three Elements That Determine Creative Success

The late Earl Nightingale, one of my favorite personal development speakers, once said, "The amount of money you make will always be in direct proportion to the demand for what you do, your ability to do it and the difficulty of replacing you."

What a great statement. The three aspects Earl spoke of are exactly what you'll need to keep in mind as you pursue your financial goals. Therefore, before you settle on an artistic niche you feel is right for you, make sure to evaluate these three important elements:

1) Is there a sizable demand for my product or service? Or is it exciting and new enough to allow me to create a demand?

When clergyman Richard Bolles first wrote *What Color Is Your Parachute?*, it was a self-published booklet to help other clergy members return to secular life. The editors at Ten Speed Press recognized the powerful career-seeking guidance in the book and asked Bolles to reslant the material to appeal to a wider audience. It was a smart move. *What Color Is Your Parachute?* has sold more than four million copies and continues to sell about 300,000 every year.

Does your area of creative expertise have a large and growing potential market? Or can you tweak the manner in which you offer your talent so that it appeals to a wider audience?

2) Am I truly good at providing this product or service, or can I improve my ability to do so?

No secret here – quality and reputation are important. For example, if you're a graphic designer, are you just one of many designers to whom your customers turn? Or are you considered to be the best at what you do? If you're not the first person that comes to mind when people need your talents, don't worry. Just set a goal to be the artist of choice and begin working toward it.

Make a commitment to master your creative line of work. If you're an actor, take classes, perform in as many plays as you can, stretch yourself and hone your craft. Determine your specialty and promote your uniqueness.

Successful creative people are not only good at what they do; they also deliver what the customer wants, when they want it. And then they follow up after the job is completed.

3) How easy is it to replace the creative product or service that I offer?

Good guitar players are a dime a dozen. But what about a good saxophone player? Chances are, the sax player will have more job security simply because he or she can't be as easily replaced.

Bill Young is an announcer whose voice you've most likely heard. He's best known for using his deep,

baritone sound on all those rock concert and monster truck show commercials on radio and TV – "Coming September 14 ... Metallica!" Young has made an institution out of his familiar yet unique voice.

One disc jockey in my area once told me that there have been a few times that agencies have hired him and asked him to "sound more like Bill Young." "I can try to imitate him, but I'll never sound just like him," the jock said. "I usually tell them, 'Why don't you just hire Bill Young?'"

The lesson here is to make your craft an extension of your unique characteristics. If the quality of your creative offering is completely based on what you bring to it as a one-of-a-kind human being and artist, your success is virtually guaranteed.

Bottom line: The level of achievement you reach will be determined by the demand for what you do, your ability to do it and the difficulty of replacing you.

Commitment statement:

"As I determine the best creative niche for me, I make sure people really want and need what I offer, that it's something I'm honestly good at and that my chosen niche allows me to corner some part of the creative market not being covered by others in my area."

Today's Action Step

It won't be hard to guess what today's activity will be. It's spelled out above.

Examine your chosen creative career path using the three questions in today's lesson. Answer them honestly and in detail.

Ideally, the answer to the first two questions (Is there a sizable demand for your creative talent? Are you the best that you can be at your craft?) should be a resounding "yes."

If your answers aren't so resounding, ask yourself what changes you could make to improve your talent and make it more appealing. Write down your ideas for improvement in these areas.

If, when answering the third question ("Are you easily replaced?"), you find there are many others who promote the talent you do, make a list of things you could do to make yourself irreplaceable.

Have some fun with this!

Day 9

Harness the Power of Questions

We've all heard, time and time again, how important it is to communicate effectively with other people. No secret here. Whether it's speaking with a director, journalist, agent, your spouse or one of your own creative peers, the way you communicate can have a great impact on your life and success.

Unfortunately, most people fail to realize that what's even more important is the way you communicate with yourself. We've already covered positive attitudes and expanding your range of possibility thinking. But what we haven't touched on are the specific patterns you've developed in your mind to make sense of the world around you.

One of the most essential ways you process information and form opinions is through the specific questions you ask yourself on a regular basis. I must credit motivational speaker Anthony Robbins for bringing this aspect to my attention through his many fine books and audio programs.

Basically, Robbins points out that your brain works like a giant computer. It takes in and stores information,

retrieves facts (in the form of memory) and operates effectively to the degree with which it was programmed.

Therefore, when you ask yourself a question, your brain assumes the question is valid and goes to work in search of an answer. When the answer is given, it becomes part of your view of the world and your place in it. The sad truth, though, is that too many people ask themselves faulty, failure-inducing questions.

How many times have you asked yourself, "Why does this always happen to me?" or "How can I be so stupid?" or "Why do I always end up on the short end of the stick?"

Ask yourself questions like these – especially when you're in a frustrated, emotionally degraded state – and your mind will look for answers. And most likely those answers will come screaming at you: "Because you're an idiot, because you have no talent, because the only way you'll ever make it in this business is to be a gofer getting coffee for other people."

Needless to say, this is not an effective way to communicate with yourself. The better approach is to ask positive, constructive questions. A couple of examples are "What can I learn from this experience?" or "How will I do things more effectively next time?" With upbeat, quality questions, your computer-like brain gives you answers that are infinitely more valuable to your success and well-being.

So the next time you're tempted to ponder a defeating thought, turn the question around. Here is a short list of weak questions and more powerful alternatives:

Weak: "How come I'm not landing any decent paying jobs this month?"

Powerful: "What can I do today to improve my personal income this month?"

Weak: "Why does my local arts scene throw up so many obstacles to success?"

Powerful: "What can I do to make the arts community in my city better?"

Weak: "Why is it so expensive to get this creative project off the ground?"

Powerful: "What options have I overlooked in getting this project done on a smaller budget?"

Monitor the quality of the questions you ask yourself on a daily basis. This may be one of the best things you can do to adjust your attitude and get yourself on track. Start to ask better questions and you'll soon find yourself a lot further down the road to creative expression and accomplishment.

Commitment statement:

"The days of asking myself debilitating questions are over. Starting now, in good times and bad, I pose positive questions and reap the benefits of finding creative solutions and profitable ideas. In fact, I'll start by asking a good one now: What steps can I take today to move myself closer to my ultimate goal of creative success?"

Today's Action Step

Take your journal with you everywhere you go today. When you catch yourself asking a negative, self-defeating question, write it down.

Then rewrite the question, turn it on its head and transform it into a question that empowers you – a question that puts the focus on finding solutions, not voicing empty complaints.

Use the examples listed earlier in this section to get started. But, ultimately, your quality questions must reflect the areas of negativity in which you need the most work, as well as the areas in which you desire the most amount of growth. So start listening to yourself ... and transform yourself into a positive-questions powerhouse.

Get some rest tonight. We'll have another busy day tomorrow.

Do You Know Who Your Ideal Customer Is?

I feel your pain. I'm not talking about physical pain, necessarily. I'm referring to the very real emotional pain and stress that comes with pouring your heart into your talent or creative business ... then still feeling like you're coming up short.

Whether you produce books, plays, movies or gift baskets, you know what you offer is good and is of value to others. It's just that not enough people seem to know about you yet and, as a result, not nearly enough money is streaming in to cover expenses, much less earn a profit.

Take heed, my fellow entrepreneur. Over the next few lessons we will begin to shed new light on how to remedy your situation (without losing your sanity or forcing you to start selling velvet Elvis pictures on street corners).

Here is the first of five steps you must follow to take charge and focus the marketing of your creative talents ... so that you start profiting from them now.

Could you sit down right now and write a profile of your ideal customer? Could you articulate how your best customers dress, where they work, what TV shows they

watch, what they do for fun and who their favorite cultural heroes are?

If you can't do that now, you'd better start searching for a way to figure it out. Knowing precisely who your customers are will dictate what avenues you use to reach them and how you communicate your message once you do reach them.

Reality: Continuing to ignore these insights will lead to missed opportunities and wasted resources. If you don't know who your customers are, where they gather, how much money they make or why they spend money, how will you ever be able to effectively promote your talents and skills in such a way that will lead to you and your customers being better off?

When you overlook this element, potential customers move on without the benefit of your creative gift; you stumble on without the satisfaction of giving something of value and getting the income and recognition that comes with it.

"It's not enough to know that a market exists for what you offer," writes Barbara Brabec in the 5th edition of her book, *Homemade Money*. "What is important is that you know – in advance – exactly how you're going to connect with it, promote to it and sell to it."

The Solution: Do some basic research. If you've already been active in your creative field for some time, ask your customers questions and write down your observations. Maybe you'll even discover a segment of the population you've been ignoring, but which could benefit from what you have to offer.

If you're just starting out, observe the types of people who patronize similar artists or ventures. Or simply describe the type of person you want your craft to appeal to. This doesn't have to be a complicated research project. Just get a solid handle on who you're wanting to reach with your promotional and sales messages. Doing so will help you attract paying customers faster – and put more money in your pocket quicker.

Commitment statement:

"I no longer leave my creative marketing to chance. Through basic research, personal observation and gut instincts, I write down specific profiles of my ideal customers. This helps me know how to reach them – and how to communicate with them once I do."

Today's Action Step

Write down the names of five people who are customers or fans of yours. Don't choose relatives or old friends. Pick people who came to know you because they admired or "got" what you were doing. (If you already have a large customer base and have a convenient way to reach them, as with e-mail, you can select a larger number of people.)

Next, contact your chosen customers and ask them if they would help you do some basic research on your craft. You can ask them individually or, if you're more ambitious, organize a one-night "focus group" meeting. However you approach it, ask these good people many

of the questions posed earlier concerning their occupations, favorite TV shows, books, hangouts, etc. Ask additional questions, whatever you feel is appropriate to understand who your customers are.

Getting answers to these questions (as well as noting the sex and socio-economic level of each person you interview) will begin to help you recognize patterns and start forming a general profile of the type of person who is attracted to your work ... which also happens to be the person most likely to support and spend money on your talents.

Way to go. You're making great progress.

Day 11

Discover What Motivates Your Customers

Now that you have a clear idea of who your customers are, you have to reach out and touch them. But the only way you'll truly reach them effectively is by knowing their real reasons for being attracted to you and spending money on your talents.

The problem is, most creative people concentrate on themselves and the features of their artistic product or service. For instance, music recording studios are notorious for promoting lists of equipment and the credentials of the engineer. That's fine, but the real reasons most studio clients spend money is to *get the good feeling* of hearing a professional, high-quality demo of their music (because of the equipment) and to *get respect* for being so closely connected to the music industry (due to the engineer's resume).

Recording studio literature and sales pitches should stress the client's feelings of accomplishment and respect. Instead, they spit out a list of mechanical features. The trick is to push a buyer's hot buttons – the deeper reason he or she spends hard-earned money.

Paul and Sarah Edwards, authors of *Getting Business to Come to You*, remind us that all potential buyers are

tuned into radio station WII-FM. It stands for "What's In It For Me?" – an essential question that every person who encounters you will ask themselves.

"Clients want to know that what you provide will meet their needs," the authors say in their book. "Can you save your customers money, time or effort? Can you increase their ability to compete? Can you make them look good to others? Can you give them peace of mind? Put yourself in the customer's shoes."

Bottom Line: Determine the real motivating feeling – the key benefit – that people experience when they spend money on you. Does your painting, book or theatre production make them feel good? Does it give them a recreational escape from their worries? Does it allow them to hang onto something they're afraid of losing (such as money, youth, sex appeal, an outlet for their frustrations)?

Ask more questions, make more observations, do your homework and use your head. Discovering the motivations that draw your customers to you will open the door to your future success.

Commitment statement:

"Just knowing who my customers are is not enough. I now take extra steps to find the true benefits that motivate people who appreciate me and pay for my talents. Discovering these hot buttons allows me to more effectively market my talents."

Today's Action Step

It's time to go back to your five (or more) selected customers and ask one more simple but penetrating question: Why do you enjoy my (writing, artwork, performance skills, craft)?

People may, at first, be tempted to give surface-level answers, such as "Because I love good art" or "You're so talented, what's not to love?" But those aren't the answers you're looking for. Dig deeper. Try asking these questions: "When you experience my work, how does it make you feel? What do you really get out of it? What sort of emotional state of mind does it put you in? What sort of physiological response does it give you?"

That's where the real answers are. Does your creative product or service pump people up or mellow them out? Does it make them tougher or more sensitive? Does it inspire your customers or make them more humble?

You need to know what hot buttons you are pushing with your best customers and fans. Because those are the buttons you'll need to push with other people like them in order to attract new customers into your creative world.

Now get busy asking those questions.

Create and Use a Brand Identity Statement

Think of your artistic talents or creative business as the steel tip of a dart. Now visualize that the people of the world are spread out across a giant wall filled with thousands of dartboards. Each dartboard represents a specific demographic group. For instance, one might be teenagers who like hard rock music while another symbolizes adults who read romance novels; other dart boards might include avant-garde theatergoers, ad agency creative directors, fans of sculpture, etc.

When you promote yourself and your talents, it's your job to aim the tip of your dart directly at the bull's-eye of the dartboards that represent your ideal customers. You do this by sending targeted messages to the appropriate newspapers, magazines, radio stations, web sites and mailing lists of potential buyers.

That's the whole point of all this customer-defining research. Once you figure out who you're ideal customers are, it's easier to determine what forms of media they patronize. You then send focused messages through those channels.

"If you're not seriously focusing on the customers you can serve best, then your business is not as

productive as it should be," writes John Graham in his book, *Magnet Marketing.* "Magnet marketing allows you to place your resources where they'll do the most good."

But what message do you send to your ideal, well-defined prospects? Most people who market a creative business make one of two mistakes:

1) Throw their dart randomly all over the wall and accomplish little or nothing

2) Aim their dart at the proper boards, but the message is so weak or confusing that the dart doesn't stick to any of them

The Solution: Create a Brand Identity Statement (BIS) for your creative endeavor. A BIS is a simple but powerful sentence of no more than 15 words (10 words or less is even better) that describes the specific vision of what you offer paying customers.

If you could take every feature and beneficial aspect associated with what you do and run it through a grinder, only to be left with the pure, concentrated essence of it ... that would be your Brand Identity Statement.

You should also craft your BIS to include a benefit statement to your customers. Two well-known examples are Domino's "Fresh, hot pizza delivered to your door in 30 minutes or less, guaranteed" (13 words) and M&M's "Melts in your mouth, not in your hands" (eight words).

The BIS I use to promote my *Quick Tips for Creative People* e-mail newsletter is "inspiration and marketing ideas for writers, artists, performers and more." And for the music newspaper I used to publish, the BIS I used to

lure potential advertisers was "Your direct link to St. Louis music and entertainment consumers."

Here are a few possible BIS's for other creative offerings: An illustrator might use "Vibrant color artwork that compels clients to read your ads and brochures." A poet could try "Personalized poetry for holidays and special celebrations." A band might use "Erotic techno grooves for sensuous souls."

Again, the ideal BIS tightly focuses on exactly what you do and how it benefits the person paying for your talents – it leaves no doubt in the prospect's mind as to what he or she gets from you.

You can use your BIS in two ways. One is internal; the other external:

Internal – A BIS keeps you focused on your marketing message. Therefore, every time you write a press release, set up a photo session, do a radio interview or design a brochure, you make certain your vision stays focused on your brand identity. You wouldn't want your business card to convey humor while your cover letter is grim and serious.

Also, a BIS keeps your marketing message tight and consistent. You don't want to send out a press release on your web design firm's new service for musicians, then do a radio interview and only have time to talk about the night you met Vanilla Ice. By constantly referring to your BIS, you make sure the messages you send out to the public stay focused on what's going to bring in the most amount of income.

External – You can also use your BIS as a personal slogan that appears on all of your ads, fliers, press

releases, banners, posters, T-shirts, stickers and more. That way, whenever someone sees your name or hears about your project, he or she will be reminded of your core identity – the main reason to do business with you.

Here are some real-life examples of BIS's in use:

- Canada's Helios Design and Communications uses "Hard-hitting design, done right the first time."

- H&B's music catalog claims to be "A mail order service for people who know jazz."

- Copywriter Luther Brock, who calls himself "The Letter Doctor," uses the phrase "High-response sales letters for firms on a limited budget."

- Chicago's Smart Studios promotes itself with the BIS "Great sounds. Cool people. Killer studio."

Find your own BIS. Then use it to stay focused and hammer home your primary marketing message.

Commitment statement:

"I no longer let winging it steer my marketing attack. I now have a powerful Brand Identity Statement about my product or service. And I use it to develop a consistent, needle-sharp vision and focused public image of my creative niche."

Today's Action Step

This one should be obvious. Get out your journal and start brainstorming on possible BIS for your unique

brand of creative expression. Don't just write one or two possible phrases. Keep your thoughts flowing and your hand moving across the page.

Take a break and reread today's lesson. As new ideas for BIS's pop into your head, write them down. Look over your growing list of statements and start rating them on the criteria mentioned earlier. The best ones should be short, to the point, descriptive, attention-getting and rich in benefits.

Take a few days or so to mull over the possibilities before deciding on a final BIS you will use. But what you must do now is use your brain to create a lengthy list of potential BIS's to choose from.

Great job! Day 13 is just around the corner.

on the Benefits of Your Creative Talents

Before you run out and start promoting your creativity to the masses, let's discuss the best ways to communicate with others – namely, your potential customers.

Start by considering the information you gathered regarding who your clients are and why they buy from you. Then use those details as you design various marketing materials, which include your:

- Brochure
- Letterhead
- Business card
- Media kit
- Photos
- News releases
- Paid ads
- E-mail messages
- Faxes
- Voice mail

- Posters
- Hand outs
- Radio interviews
- Direct mail pieces

As you create these marketing communications, keep one thing foremost in mind: the needs of your customers. In other words, stop talking so much about yourself, your needs and your qualifications. Start talking about what matters most: the benefits your customers get when they do business with you.

"The objective here is plain," says marketing guru Jeffrey Lant. "It is not merely to tell what you've got ... it's to motivate a human being to take immediate action so you can move to the next stage of the marketing process." Lant has self-published more than 10 business books and has sold thousands of them using the same tactics he preaches about in them.

In his excellent tome, *No More Cold Calls*, Lant advises, "You must list every feature of your service, transform every one into a benefit, then make sure the benefit is as specific and enticing as possible."

Let's see how this works in the real world. As an example, I'll use the way I've marketed one of my music business audiocassette programs. I'll list each feature first, then its corresponding benefit.

Feature: Sixty minutes in length.

Benefit: Packed with a full hour of money-making details you can start using the same day you receive it.

Feature: Available only in audio format.

Benefit: You get the convenience of being able to soak up these useful success secrets at your convenience – while you drive, jog, ride a bike or clean the house. Audiotapes make learning easy.

Feature: Order with a credit card online or by phone.

Benefit: Why wait? Start making more money sooner by taking advantage of this convenient ordering option. You'll have the tape in two days if you order with your credit card now.

Sure, the examples I use above are admittedly filled with hype, but they illustrate the need to focus on benefits. Your promotional tone should reflect your identity and the people you're trying to attract.

Are you getting the idea?

Commitment statement:

"I transform every feature of my creative product or service into a benefit that my clearly defined audience of potential customers finds irresistible."

Today's Action Step

You should be getting used to reaching for your journal at this stage of every lesson. Well, here we go again.

Draw a vertical line down the middle of a blank page. At the top of the left column, write "Features." Over the right column write "Benefits."

One by one, list the features of your creative offering. Include the specific details of the product/service you offer, hours of operation, years you've been in business, your educational credits, awards you've won, colors, sizes, shapes and a whole lot more.

It's possible that you already list these features in your marketing materials. And you probably assume that your customers and prospects are smart enough to figure out how these features benefit them. But I insist that you don't count on that happening. You must tell them, in no uncertain terms, what's in it for them.

Now go through your list of features, item by item, and in the right hand corner describe what that feature means to the customer. The simple rule of thumb is this: Features focus on the product or service and its attributes in "I," "we" and "it" terms, while benefits focus on the customer in "you" and "your" terms.

Take another look at my audiotape example above if you get off track. Otherwise, fill out both columns in your journal. Transforming your talent's features into riveting benefits will move you another step closer to a profitable career as an artist.

Keep up the great work. See you tomorrow.

Day 14

Stop Talking So Much About Yourself

I know it seems like we've beaten this premise to death, but it's so crucial to your success, I feel I must discuss it again. So just in case it hasn't sunk in, let's drive it home one more time: Make certain your words – whether in person or on the phone, in ads or sales letters, in e-mail or on your web site – focus on the benefits to your customers.

Time and time again I explained this essential concept to some of the business owners who advertised in the music newspaper I used to publish. And, sure enough, when they turned in the wording for their ads, they were filled with "I can do this, we've done that, I, me, mine ... blah, blah, blah!"

Reality: Human beings naturally gravitate toward talking and thinking about themselves. And for good reason. For millions of years, members of our species had to think about their own needs in order to survive. In the caveman days, if you weren't consumed with self-preservation, you'd be consumed by any number of wild predators, not to mention being done in by members of rival tribes. There's a long-standing tradition of human self-indulgence.

You may not be able to wipe out millions of years of conditioning in a couple of days, but you can use your advanced, reasoning brain to decide to resist these primitive urges when it comes to marketing your creative pursuits.

Also, realize you can use this knowledge of human nature to your advantage. When you approach potential clients through your performances, exhibitions, brochures, business cards, mailing pieces, etc., who will they be focusing on? Don't kid yourself and think it's going to be you.

Knowing this, give customers what they want and make sure your marketing message hits them squarely between the eyes with what's in it for them. Lead off with the number one benefit they get from you, followed by the number two benefit and so on. Pile the motivating reasons they should buy from you one on top of the other until even the most thickheaded of humans can figure it out.

Specific example: Let's say you were put in charge of marketing a new electric drill for carpenters. How would you go about it? Most people would start listing features, such as the drill's manufacturer, mechanical specs, materials it was made of ... all focusing on – you guessed it – the drill.

But what do people really want when they buy a drill?

A hole.

They also want a hole that can be created quickly, easily and economically. It doesn't matter if the hole gets there because of a drill, a toaster, a pair of socks or a

monk – as long as the appropriate hole is conveniently creating in the right place.

In other words, sell the hole, not the drill. Then, and only then, use your features to show how your drill can meet the customer's specific needs.

Want an example? Here is some text from the ZoomTone Records web site:

"Imagine the intimacy of a song whispered into your ear, so close it raises goose bumps. ZoomTone Records gives your ears what they deserve: real magic from real music captured alive and breathing by the new technology of SACD."

Notice how this approach paints a picture that entices readers by letting them know how they'll benefit from what ZoomTone offers. Make sure you do something similar when describing your creative product or service.

Commitment statement:

"I resist the human urge to talk about myself in selfish terms and, instead, focus on what my customers are most interested in: what's in it for them."

Today's Action Step

Guess what? There will be no journal writing today. Your fingers will get a break, but your mind won't.

What I'd like you to do is gather together all of the marketing materials you've used over the last couple of

years. I'm talking about everything: brochures, sales letters, fliers, business cards, rate sheets and more. Even print out copies of e-mail marketing messages you send out and the pages of your web site.

Now go through your material and observe how much you talk about yourself. Be brutally honest. How many of your sentences and paragraphs focus on you and the artist, product or service? How many focus on what the customer gets? Notice what your headlines and opening sentences zero in on.

Use two different colored highlighters. Go through each marketing piece and highlight in one color every reference to "I, me, my, we, our" or some similar focus on you. Then, in a different color, highlight every customer reference to "you, your, yours."

Your goal is to have twice as many items highlighted in the second color. If not, you have a lot of work to do. If you do have more *you*'s than *I*'s, congratulations. You're on your way to putting your marketing energy where it needs to be – on the people who are most likely to help you prosper: your present and future customers.

Hey, you're half way through the four-week workshop. Congratulations!

Day 15
Set Specific Income Objectives

We all know people who are gifted at a particular creative skill –making music, writing short stories, painting landscapes, doing choreography, etc. But only a select few of these artistic folks ever rise above the fray and experience substantial success. Even creative types who are sharp and personable and appear to be driven often run out of gas. And they end up abandoning their talents in frustration.

Why is that?

Well, after meeting and observing successful people with a curious eye, I've come to the conclusion that creative individuals who move beyond ordinary levels of achievement do a few simple things differently. While these basic actions and attitudes are indeed simple, they make all the difference in the world.

Now that you've completed the first 14 days, your mind and attitude are focused and determined to achieve success. And now that you've chosen the creative field that's best for you, it's time to get busy and start making money.

Great, but how much money? If your only answer is "As much as I possible can" or "Whatever I can get," you may be in for trouble.

Make no mistake. To keep from becoming a wandering wannabe who only talks about staking a claim with his or her talent, you have to know how much money you want to make. In other words, you must set income goals. You must know – in advance – what specific dollar amounts you need to generate to meet the income level you've set for yourself.

Setting revenue objectives will:

- **Keep you focused on your money-making efforts**. Setting income goals helps keep you on track. Without them, you'll aimlessly plod through selling your creative product or service without an inkling of how well you're doing financially. Which leads to empty pockets.

- **Give you a gage by which to measure your progress**. When you start bringing in money, you need to know whether you should celebrate or go back to the drawing board. Income goals help you figure that out. If you bring in more money than you expected a couple months in a row, it's probably time to up your dollar amount objectives. If you're far below the amount you set, that's a sure sign that you need to rethink your approach.

- **Ensure you don't absentmindedly slip too far into debt**. One of the worst things you can do is continue to sink money into a new creative venture, only to find – after it's too late – that

your cash flow isn't as much as you thought it was. Don't get strapped with growing debt. Income goals help you monitor your progress so you can avoid trouble as soon as you see it coming.

You'll also need to write down your income goals in yearly, monthly, weekly and even daily and hourly terms. For instance, $24,000 gross revenue a year equals $2,000 per month, about $462 per week, $92 a day and $11.55 an hour (based on a 40-hour workweek).

Break the dollar amounts into bite-size chunks. It's a lot easier to drum up $462 in paid work this week than to worry about the entire $24,000 for the year.

Income objectives should be moderately set. You don't want to make the dollar figures too high and then be disappointed when you can't reach them. On the other hand, setting them too low will leave you feeling unchallenged. Set your income goals so you have to stretch a bit to reach them. It'll make the payoff that much sweeter.

Also, everyone has his or her own comfort level. Some would be happy with an extra $500 in spending cash a month while others will need to make that much per hour to be happy. Do what's best for you. But take the first important step toward defining your income objectives. And do it now!

Commitment statement:

"In order to make the money I deserve, I set specific income objectives to keep me focused and on track. I express these goals

in yearly, monthly, weekly, daily and hourly dollar amounts.
Doing so helps ensure that I earn the creative income I desire."

Today's Action Step

It's journal time again. Turn to a fresh page and ponder today's lesson. How much revenue do you realistically want to generate from your talents? Start with whatever time increment makes sense for you, whether it's a daily, weekly or monthly amount that comes to mind.

Let's say you're pursuing your creative passion part-time to start and you'd like to bring in an extra $500 a month. Using that $500 per month figure, fill in the other increments. Multiply by 12 months to get the annual amount (in this case, $6,000). Divide that annual figure by 52 to get your weekly amount (about $115).

Divide that weekly amount by the number of days per week you have to spend time on this craft (that figure could be all seven days or, if you only have weekends available, just two days per week). Let's say you only practice your craft on Saturdays and Sundays, so each day you must generate $57.50. And, of course, you could break that down further into hourly amounts.

Once you have these hard numbers in front of you, you can begin to determine if your profit margin on the creative product or service you offer will allow you to bring in this kind of money.

Also ask yourself: How many sales will I have to make per day or week to reach my income goals? What

methods of promotion will best generate enough paying customers?

Admittedly, this isn't the most fun part of our four-week journey. But it's a part that will help lead you to more success with your creativity in the long run. And that can translate into lots of fun and satisfaction in your future.

Tomorrow we'll cover another important aspect of earning money as an artist. See you then.

Day 16

To Get What You Want, Help Others Get What They Want

I truly believe that a lot of people don't become successful or make much money because they consider themselves to be in the taking business. Their only concern is what they have to do to take someone's money away from them.

The thing that drives these poor creatures is the prospect of jumping on what's going to make the fastest buck, regardless of what it is or how it's done. But I pity them, and so should you, because they'll never know the joys of being in the full-time giving business.

Being a success in the field of creative giving means that the talent you specialize in adds real value to the lives of the people who become your customers.

Of course, the thing that makes you happiest is being directly involved in an area of creativity for which you have a burning desire and passion. But the aspect that will make you financially comfortable (and even happier) is making sure your customers feel that what they get from you is worth more than the money they have to part with.

For instance, a successful magazine writer gives her editor a reliable source of content that makes the editor look good in the eyes of peers. A photographer gives his client a hot, new image and boost of self-confidence. A music teacher gives her students the ability to make music and impress friends.

Get the picture?

If this concept of giving sounds familiar, it's because we covered an aspect of it on Day 13 and 14. Creative giving ties directly into delivering benefits.

In other words, make sure you have a firm grasp of what people get when they hire you or purchase your goods. Once you know what that payoff is, you'll know how to communicate with customers and keep them coming back for more – while referring you to others.

Concentrate on what you *give* to the people who send money your way. If you continue to give what they want and need, you won't have to worry about taking anyone's money. It will take care of itself.

Commitment statement:

"While pursuing my creative interests, as with life in general, I have to give to others before I can receive any rewards, financial or otherwise. Therefore, I focus on what I give in order to get the income and recognition I want."

Today's Action Step

I want you to consider two separate but related thoughts today. Then find areas in which they overlap.

Here's what I mean: First, think about the various people in your life who are recent customers or potential customers. Think about conversations you've had, areas of mutual interest, the goals and aspirations these fine folks have, etc.

Second, think about the resources you have at your disposal – other people you know, books and magazines you own, web sites you've visited, clever ideas you've come up with.

Now see where all these people and things overlap as you concentrate on a new attitude of giving. One of your customers might really appreciate you mailing a copy of a magazine article you know she'd be interested in. Another might be surprised by you calling just to pass along the name and number of a contact he could use. Other prospects would be impressed with you sharing some advice on projects they're working on.

And you'll be doing all of this without expecting anything in return.

The amazing thing is, if you make a habit out of this unselfish attitude of giving, you will indeed get overwhelming rewards in return.

We'll talk again tomorrow.

Day 17

Put a Priority on Marketing Your Talents

After having let myself slip into the hypnotic pattern of performing daily tasks, I know how easy it is to fall into bad marketing habits. Luckily for my business and my bank account, these shortcomings are a thing of the past (for the most part).

What I'm referring to is the trap of getting so wrapped up in the day-to-day routine of exercising your craft and tending to mundane details that you put your self-promotion efforts on the back burner.

For instance, you have to pay the bills, balance the books and make sure your current customers are being given proper service. Plus, you've been wanting to organize that messy storage room for months now and you've got a stack of magazines that haven't been read yet … oh, and look who's on *Oprah* this afternoon.

The excuses flow freely and seem justified, but in the end if you keep blowing off marketing activities you'll find yourself in the middle of a month with only half of your usual income and all of your normal expenses. And you'll wonder, "What happened?"

Avoid this trap by treating marketing your creative product or service as an activity that gets the same priority as eating, sleeping and putting clothes on before you leave the house. In fact, you'd be wise to set aside a specific period of time each day and devote it to nothing but promotion and income-generating activities. During this time, do at least one of the following:

- Compile, rent or trade for a list of media contacts who might be interested in what you do – writers, editors, radio disc jockeys, TV show producers, web site owners, etc.

- Develop creative news hooks that might interest these media people in covering what you do. Then write and send press releases based on these news hooks.

- Send press kits, samples or review copies to the proper media contacts and follow up with phone calls or e-mails to each until you have a steady stream of press on your talent or creative business.

- Create an inexpensive item you can give away for free (for example, a recording studio might offer a short report called *Cut Your Recording Costs in Half: 12 Ways to Save Money on Your Next Studio Project*). Of course, this freebie will also contain a message on how people can benefit from what you offer. If you aggressively promote such a freebie, you'll soon have a sizable mailing list of people interested in what you do.

- Send e-mail, post cards and direct mail pieces – filled with benefit-rich wording – to your list of

potential buyers at least six times over the next 12 months. After that you can weed out freebie-seekers who don't buy and mail more often to those who make purchases.

- Make follow-up phone calls to people who've expressed an interest in doing business with you.

- Call (or send mail to) people who've already purchased from you and make them aware of new music, books, paintings or performances you have to offer. It's always easier to make additional sales to people who've already bought from you than it is to find new customers.

There are an infinite number of other marketing activities you can add to this list, but use these suggestions to get started. And do something off your marketing list every day.

Commitment statement:

"Marketing is not something I do when I can get around to it. I make marketing my creativity a regular, profit-boosting part of my day. Making this a priority brings me great financial rewards."

Today's Action Step

Today you're going to draw a map of your weekly activities. You can either create a seven-day schedule in your journal or use the pages from an old week in an appointment book – as long as you have a clean column

for each day of the week and enough space to separate mornings, afternoons and evenings.

Now go through your average week day by day. First list the things you have to do: the time you spend at a day job, the time you spend with your kids and other important obligations.

Then list other activities you normally engage in. This can include regular nights you have set aside for rehearsals or writing or painting; the Saturday afternoons you always reserve to spend time with your spouse; nights you take classes, etc.

Now look at where the open spaces are. Find time in your schedule every day (or at least close to every day) during which you can invest energy in one of the marketing activities listed earlier in this section.

Be realistic. Don't plan to do marketing on days when you'll most likely be too exhausted to do it right. But don't find easy excuses for flopping down on the couch and putting it off, either.

If your schedule seems tight with little time available, ask yourself what sacrifices can be made. What current activity (or diversion) can you drop in favor of beefing up your marketing attack?

Once you find these slots in your schedule for marketing efforts, etch them in stone. Give them the same weight as picking up the kids from day care or buying groceries. Then stick with the plan.

Doing something, no matter how small, every day to market your talents will pay itself back tenfold in the not too distant future. See you on Day 18.

Day 18

Seek Out Unconventional Promotion Opportunities

As we discussed in yesterday's lesson, there are an infinite number of strategies you can use when promoting, marketing and selling your creative skills and talents. With a little brainstorming, you could soon have a lengthy list of high-impact ways to reach an audience of potential fans and paying customers.

Why, then, do so many creative entrepreneurs cling to only the obvious marketing routes, never taking the time to discover and pursue less-traveled (but highly effective) promotional paths?

As we've talked about before, it's the age-old dilemma of tunnel vision. It's so much easier and more comfortable to go with a short list of traditional methods than it is to exert brainpower on conjuring up new, creative ways to cultivate new clients and fans.

Want some examples of shortsightedness?

Let's say you're in a dinner theatre troupe that is opening a new murder mystery. To promote it, you send press releases and invitations to regional newspapers and radio stations. Then you throw an opening night party at the venue where the performances will take place.

And that's it.

No more attempts are made to send attention-getting news concerning the production out into the world. And the cast members and producers will say, "We've done all we can to promote it," then wonder why only 30 people attend the entire first weekend.

And what about the photographer who desires to make some decent money by specializing in band photos and album cover shots? She runs classified ads in local newspapers and pins up fliers at music stores, then sits at home and waits for the phone to start ringing. She gets a few calls, but after three months she's only landed five low-paying photography jobs. What else can she do to create more business?

The answer: a lot!

"If you're a small company, a new venture or a single individual ... you've got to be fast on your feet, to employ a vast array of marketing tools," writes Jay Conrad Levinson, author of the *Guerrilla Marketing* series of books. "You may not need to use every weapon in your potential marketing arsenal, but you're sure going to need some of them. So you'd best know how to use them all."

What if our photographer friend sat down with a pen and writing pad and started challenging her mind to come up with effective, low-cost ways to promote her services? She might even ask herself, "What are some things I can do, starting today, to promote my photography business on a small budget?" (Remember the power of questions from Day 9?)

Before long, she'd start writing down lots of ideas, such as hooking up with a recording studio and offering to give one of its clients a free photo session. The studio could hold a drawing and even advertise that fact in its display ads (which wouldn't cost the photographer a dime).

Or she could write and print a simple one-page newsletter filled with tips on shooting and marketing quality band photos. Whenever she encounters anyone who might be a possible customer, she'll offer to put the person on her mailing list for free.

By constantly adding to her list and regularly sending out newsletters, she'll keep her name in front of musicians. And when they need a photo, she'll probably be the first one they think of.

And what about our dinner theatre troupe with the new murder mystery? If the members took the same creative approach, they'd also have a list of innovative marketing ideas.

Perhaps they could arrange a series of free sample shows at local art galleries or coffee houses. That way they'd not only reach people in those locations during these free performances, but they'd get weeks of extra publicity through posters announcing the free shows.

Or what if they added some extra punch to their opening night party by getting local merchants to donate door prizes – maybe a stereo system, record store gift certificates or even a weekend trip through a travel agency?

And if something about one of the actors or maybe the subject matter of the show could be tied into a

specific cause or charity, they may be able to use that to give the party an additional theme – and a great media hook, to boot.

By now I don't need to remind you, but I'll do it again anyway: Look beyond the tried and true. Stretch your imagination. Challenge your mind to come up with creative ways to get more people talking about you, covering you in the media and buying from you.

Opportunities are sitting right under your nose. All you have to do is look for them.

Commitment statement:

"When marketing and promoting my creative business, I resist the urge to stick only with obvious methods. There are gold mines of overlooked promotional opportunities waiting to be discovered. And I have an ongoing, burning desire to find them."

Today's Action Step

We're going to have some fun today and use a brainstorming technique to help us uncover some uncommon promotional tactics.

Turn to the next blank page in your journal. Draw a vertical line down the middle of the page. State your particular creative offering in two simple words. The photographer might write "Band Photos." The theatre troupe guy might write "Murder Mystery." Let's use the latter as an example.

Write "Murder" at the top left and "Mystery" at the top right. Free associate with the word "Murder" and under it write the first five words that come to mind. Do the same under "Mystery." Don't feel you have to stick with obvious references to the product or service. Go off on tangents. You may end up with a page that looks something like this:

Murder	Mystery
Killer	Suspense
Chalk Line	Sphinx
Detective	Sherlock
Clue	Unsolved
Butler	Blind Date

Now randomly pick one word from the column on the left and one from the column on the right. Put them together and see what ideas come to mind. Play with this and have some fun.

Let's say you combine Clue and Blind Date. This might lead to the idea of pitching your performances to singles groups. At the beginning of the night, each attendee is given a clue that can only be deciphered when matched with one other person's clue. Attendees must then discover who has their corresponding clue.

Next you combine Butler and Sphinx. This line of thought leads you to ponder someone who serves food in an exotic, faraway place. Then you might ask: What if our dinner theatre specialized in a specific type of ethnic

food, instead of the predictable, standard fare? Italian murder mystery, anyone? How about Chinese dinner theatre?

Now that you're on a roll, you decide to match up Chalk Line and Sherlock. Instead of a body outline, you think about a classroom chalkboard ... then Sherlock Holmes. What if you held a contest to see who could draw a picture of Sherlock Holmes? The top 10 winners get free tickets and you get whatever free publicity is generated as a result of the contest.

I hope you're beginning to realize that good ideas are out there waiting to be discovered. You just have to motivate your brain to stretch to find them.

Happy idea hunting.

Day 19

The Power of Repetition and Ongoing Promotional Assaults

Today's lesson relates directly to yesterday's message. When you pursue only a handful of the promotional possibilities available to you, you ignore dozens of other marketing opportunities. You also cheat yourself out of the magic created by Ongoing Promotional Assaults (or OPAs).

The OPA concept boils down to this: Hit potential customers with your Brand Identity Statement (BIS – from Day 12) from as many different angles as possible.

Keep in mind that the people you're targeting are slapped with thousands of messages every day. From television, magazines and junk mail to radio, billboards and ads on city buses ... they are literally bombarded with marketing intrusions. To cut through all that clutter, you have to reach your customers not just once or twice, but several times with your well-defined, what's-in-it-for-them message.

That's why it does you no good to be timid about your approach, and why it's futile to expect that one or two attempts to reach your audience will have much of an impact.

According to a study by Bell Labs, a single issue of the *New York Times* contains more information than a 16th century adult had to absorb over an entire lifetime. Obviously, people today are overwhelmed with stimuli. "To keep from getting lost in that flood, you've got to repeat your message as frequently as possible," writes John Graham, author of *Magnet Marketing*.

To cut through and even hope to make an impression, you must have a plan to reach potential customers repeatedly through a variety of sources. Then, and only then, will many of them recognize that what you have to offer is beneficial to them.

The next logical step – that is, if you've laid the groundwork – is for customers to call you, place an order, buy your product, pay you to perform your creative service, etc.

Your promotional assault arsenal should include exposure through some combination of the following:

- National magazines

- Regional and local newspapers

- Specialized newsletters that cater to your target audience

- College, community and commercial radio stations

- Broadcast and cable TV stations

- Online tools such as e-mail, newsgroups and web sites

- Fliers and posters that get hung up at appropriate stores and retail shops

- Venues at which your talents might be displayed

- Retail stores where your product or service might be sold or promoted

- Post cards, self-mailing fliers and other direct-mail pieces

- Your business cards and letterheads

- Merchandise and advertising specialties such as T-shirts, caps, stickers, memo pads, novelty items, etc.

There are more options we could add to the list, but this gives you an idea of the many ways you can reach people on a myriad of levels.

Your mission is to come up with an ongoing plan that will cover your target audience with a series of marketing coats. Each one builds upon previous coats by making more people aware of what you do, and making more of an impression with the people you've reached before.

To illustrate the point, let' say you're an oil painter. Do you think that having an exhibit at one or two galleries, getting a write-up in the paper and being interviewed on a radio station will be enough to ensure your long-term success? The truth is, they probably won't.

But those accomplishments would add up to a good start if you follow them up with an appearance on a cable TV show, mailing regularly to your growing customer list, plastering targeted retail shops with your fliers, setting up a fan-friendly web site, giving away business

cards with a description of what you do and why people should care.

The same tactics can be used for just about any creative product or service.

Find a way to get members of your target audience to see your name (and your well-defined, benefit-oriented message) at least several times within the course of a year. And make sure they hear about you from a variety of different sources. That's what effective Ongoing Promotional Assaults are all about.

Note: This campaign of continually reaching your prospects with a series of strong marketing messages doesn't have to be a big-budget affair. All of the methods discussed here can be done for relatively little money. Which means your list of excuses for not doing it just grew shorter.

Commitment statement:

"I am now a practitioner of Ongoing Promotional Assaults. From now on I will launch a series of friendly assaults on my ideal customers – and I'll make sure they hear of the creative benefits I offer on a regular basis from a variety of sources."

Today's Action Step

It's time, once again, to put the words you just read into action. Look over the categories of possible promotional tools listed earlier in this section. Also review some of the novel ideas you generated during

yesterday's brainstorming session. Feel free to add any new ideas you've come up with to your list of marketing weapons.

Next, sketch out a six-month schedule of OPAs. Jay Conrad Levinson, of *Guerrilla Marketing* fame, calls it a "marketing calendar." He advocates breaking down your plan into a list of weekly activities. But each promotional weapon you use isn't limited to a one-week duration. Some tactics you might run for four weeks straight with other short-run assaults overlapping the longer ones.

The primary reason to create a calendar is to make sure you have a plan – a roadmap to follow along the way. Be sure to consider the costs and time requirements of each tactic you plan to implement. Balance these factors so you don't have weeks or months when your resources are tapped out. Also, make sure you have a variety of angles covered – mixing Internet marketing with print media and direct customer contact.

Having a calendar to follow will give your Ongoing Promotional Assaults a backbone ... which will lead to more recognition, more profits and more fun for you and your creativity.

Day 20

Ask People for Their Help and Their Business

Several years ago, my small staff and I were getting ready to organize our second annual Regional Music Showcase conference in St. Louis. I hesitantly contacted the marketing director of a big local company to inquire about his interest in sponsoring the event. The year before, I had assumed this particular corporation wouldn't be interested because we didn't have enough clout yet to gain its support.

Expecting a cold response even in our sophomore year, I was shocked by the marketing director's first remarks: "I was wondering why you didn't invite us to participate last year."

The problem was, I hadn't asked. An entire year had to go by before I took the steps that revealed this golden opportunity. *Lesson*: If you don't ask, you usually don't get what you want.

This concept works on many different levels, but primarily it boils down to this: Success of any kind translates into lots of people taking lots of action. For instance, for a band to have a hit record, the members have to work hard to write and record their music. The publicity people at the record label need to expend

energy on getting press coverage. The radio promotions folks and distributors have to do their jobs. Plus, fans have to attend concerts and buy CDs.

The same goes for a successful comedian or sculptor. A lot of busy work has to take place in order for progress to occur and money to be made. One way to inspire all of this human action is to ask for it. Don't be shy about asking someone to do something to help you – as long as it's in his or her best interest to do so.

This is especially true when asking a potential customer for a first sale or a past customer for a repeat sale. I've known sales people who knew their product like the back of their hand, had the gift of gab and knew how to personally connect with potential buyers. But when it came to asking for an order, they withdrew – and lost lots of income in the process.

Nobody likes a pushy, brash sales person. But if what you have to offer can genuinely benefit the other person, by all means, ask for the order – whether you're wanting the person to hire you as an artist, book your band, assign a story to you, cast you in a show ... whatever. You know the wise, old motto: Ask and you shall receive. It's wise and old for a good reason. Because it's true. Especially when it comes to succeeding with your creativity.

And while you're getting over your shyness, start asking people for things other than money, such as:

- Ask satisfied customers to call retail outlets and request that they carry your book, art, photographs, etc.

- Ask acquaintances for referrals of people who might want to do business with you.

- Ask your more successful creative peers for tips on how you might promote yourself better.

- Ask vendors and suppliers for better prices or credit terms.

Remember, by asking, you can set a lot of people in motion doing productive things while giving yourself some nice advantages – which leads to the type of action that brings you success.

However, while you're doing all of this asking, make sure you're *giving* at least as much in return. In fact, it would be even better to get into the habit of freely giving referrals, information, compliments, suggestions and more without expecting anything in return. That way, when you really do need something, people will be even more eager to help you get what you want.

And all you have to do is ask.

Commitment statement:

"I am confident and secure when it comes to asking people for their help and their business. I no longer beat around the bush or am shy. By regularly offering help to others, I am not only a better human being, but it puts me in a prime position to ask for return favors."

Today's Action Step

Are you ready to make some lists? Good. Today we're going to make lists of people from whom you can ask for help.

First, though, make a list of different types of people who are involved in your creative life. People on this list would include paying customers, people who support and encouragement you, members of the media, people who offer similar but noncompetitive creative services, direct competitors, influential people in your field, etc.

Within each category list the specific names of people who may be able to help you. Then list the specific request you will ask of them. This list might include:

- Contacting a recent customer to make her aware of a new service you offer ... and asking for an order

- Asking supportive friends and family members to help you post fliers or make phone calls to promote an event

- Getting in touch with a local columnist to ask him about the possibility of a story idea

- Contacting direct competitors and those who offer similar creative services and asking about teaming up for a cooperative promotional campaign

- Asking people who run influential associations for their help in getting the word out about your efforts

Once you've got a complete list of people and requests, look them over and determine which ones would best to start with. Then … ask, ask, ask … while giving in return. Do that and the world may start to open its arms to you and your talents.

See you tomorrow.

Day 21

Use Powerful Testimonials and Success Stories

Let's recap some of the marketing lessons you've learned thus far. You know that in order to succeed, you've got to lovingly slap people in the face time and time again with your promotional messages. And you've got to give them one strong benefit (the real reason they buy from you) after another to effectively grab their interest. But still, many folks will be leery.

Why?

Because even if you are on target with and sincere about the great creative goodies you offer – and even if you are focused on customer benefits – that often isn't enough to motivate people.

The solution: Use testimonials and customer success stories. Endorsements give validation to your product or service from a third-party source – supposedly, a source that isn't as biased as you. Testimonials create powerful reasons for people to spend money on your creative offerings. Testimonials and success stories come in many forms, including:

- Comments from satisfied buyers
- Excerpts from magazine and newspaper reviews

- Reprints of sales charts or award certificates

- Radio station airplay lists

- Best-seller lists

- Specific results a certain customer got after experiencing your talents

Here are some examples:

An author might include a quote from a review in which the writer remarked, "This book provides all the steps you need to turn your child into a grade-A student." The quote would, of course, be followed by the name of the publication it appeared in. Including the writer's name is optional – many publicity people only list it if the reviewer is well known.

A dance instructor could include a quote from a client saying something like, "I've learned more from three months of dance lessons from Nancy than I did in three years of lessons from other instructors."

You can also list statistics without an actual quote from someone. For instance, a literary agent could boost that "Six out of the last 10 authors I've worked with received five-figure book deals. How would you like those odds working for you?"

Can you see how comments like these in your promotional literature can add real muscle to your sales pitch?

Starting today, begin a program of gathering as many testimonials, success stories and third-party endorsements as you can. Set aside a file folder labeled "Testimonials." Every time a review or feature story appears in the press, clip out the page and put it in this

file. The same goes for sales charts, awards and any published ratings or test results.

Also, keep your ear open for comments from satisfied customers. (If you're delivering the satisfaction you know you're capable of, you should be hearing these words of praise often. If not, you'd better start finding out why.)

When someone does say something complimentary about your creative product or service, let that be a cue for you to ask the person politely if you could use his or her comment and name (remember what we discussed yesterday about asking for things).

Jot down the comment while the person is standing in front of you (or while you're on the phone) and read it back. *Important*: Do your best to get the customer to phrase the testimonial so that it clearly states specific benefits.

To demonstrate, here are two testimonials I got a few years ago from business owners who advertised in my former music magazine. Which do you think is stronger?

A nightclub owner said, "*Spotlight* has been a real positive thing for the local nightclub scene." Nice. But compare that to the music store manager who offered, "Our phones were ringing off the hook during our annual guitar sale, due in large part to advertising in *Spotlight*."

Hands down, the second testimonial is the winner. It spells out a direct customer benefit and gives credit to the product.

Try to get similar types of quotes from your customers. And when you do, place them right away into

your testimonials folder. Then, any time you put together a flier, post card, brochure or web page, sprinkle some of these endorsements throughout it. It will add a concrete foundation to the rich benefits you're already offering your customers.

Testimonials give you more credibility. And they also inspire people to experience your creative skills and spend money on you. Collect them, save them and use them often.

Commitment statement:

"I don't rely on my words alone to promote my creativity. I regularly gather and use third-party testimonials and success stories to hammer home the benefits I have waiting for my customers and fans to enjoy."

Today's Action Step

Let's keep today's activity simple. Since I know you fully grasp the importance of today's lesson, all you need to do is pick up your journal and make a list of people you will contact and ask for a testimonial.

Then start making calls, sending e-mail and writing letters ... whatever you must do to connect with the people on your list – and politely ask for their strong words of endorsement.

Also, think about awards, reviews, sales charts and other notable items you can use as third-party endorsements. Grab a file folder, label it and place it in a

prominent location. Then, start filling it with the wonderful quotes and achievements you will surely collect.

Until tomorrow.

Day 22

Make It Easy for People to Connect with You

I've seen this moneymaking mistake hundreds of times.

A band runs an ad in a local paper announcing its new CD release. That's great, but I have a couple of questions: Where is the CD available and how can I get on the band's mailing list to be alerted about upcoming concerts? Well, I'm out of luck because the band failed to include that important information in its ad.

Or what about the freelance writer who sends out a promotional letter hyping her talents and availability to newspaper editors? Her letter is wonderfully written and filled with active, customer-friendly wording. And she gives great reasons for people to call her.

The only problem is, most people who call get her answering machine – and there are lots of people who don't like dealing with answering machines. She could be losing hundreds or even thousands of dollars worth of business by only giving potential clients one route to communicate with her.

Different people respond in different ways. So give them several (or at least a few) easy options to get in

touch with you. In addition to a phone number, you should offer a few of the following:

- **A mail option**. Any promotional letter can be crafted to include a section at the bottom to be used as a response coupon. Interested clients can simply check the appropriate boxes indicating their interest and mail back the coupon.

- **A fax option**. People love the immediacy and convenience of fax machines. Allow customers to mail response coupons back via fax.

- **A pager option**. Are you hard to reach on the phone? Get a pager and offer this quick-response tactic. Just make sure to always bring your pager with you and return calls quickly – while your prospect is still warm with interest.

- **An e-mail option**. It seems most people these days are connected to the Internet. List your e-mail address as a way to contact you. Doing so will enable you to receive marketing responses in seconds instead of days (while saving a good chunk of change on long-distance phone bills).

- **An e-mail autoresponder**. Using this option, you can respond to people while you sleep. An autoresponder instantly sends a return e-mail to anyone who sends a message to a predetermined e-mail address. Use an autoresponder to send an order form, price list, free article, performance schedule, etc.

- **A telephone hotline option**. Creative people and companies of all kinds should consider using a hotline to provide interested customers with

helpful tips, new product announcements and special sale prices. Voice mail firms can supply you with a phone number and outgoing message for as little as $10 a month.

- **A web site**. This is a no-brainer, but just in case you overlooked it ... Place information about and images of your talents on a web site and direct potential customers to it when they want more details about your craft.

- **A fax-on-demand option**. This service allows a customer to call a special phone number with her fax machine, punch in the appropriate numbers and automatically receive pages of information sent right to her fax machine. If you don't have the computer equipment to handle this, there are service companies that provide it.

How much more of a response would you get from your marketing mailings, ads, fliers, business cards and brochures if you gave recipients some or all of these options to connect with you? I think you know the answer: a lot more!

The same goes for your dealings with the media. Put your name, address, phone number, e-mail address and any other options to reach you on every piece of publicity material you send out. It's important to remember that photos and bios get separated from each other. So does your CD, cassette, product sample, novelty item, etc.

There's nothing more frustrating for a newspaper editor than coming across a generic photo with no name or phone number on it. "Who is this person?" I always ask as I pitch a photo into the trashcan.

Whether you're trying to reach the media or your customers – whether it's through the mail, a display ad, a radio spot, the Internet or a flier on a bulletin board – always make it easy for people to connect with you. Doing so will help ensure that you connect with success.

Commitment statement:

"I no longer leave my communication with potential customers and media sources to chance. I make it easy for interested people to contact me to get the creative benefits I offer. And I give people several options to do so."

Today's Action Step

I'm sure you're sold on the idea that providing many ways to contact you is good. Now you must decide how many options you will supply. Go through the list presented earlier in this section and answer these questions:

- Which ones make the most sense for you?

- How many can you afford?

- Which options would allow you to follow up the fastest?

- Which ones would be the easiest for you to implement?

You wouldn't want to list your e-mail address on all of your outgoing brochures if you only go online once a week to read e-mail. The same goes for using a post office

box as a physical address. Unless you pick up your mail at least a couple times a week, using the box as a contact method defeats the purpose of quick follow-up.

Write out your thoughts on each of the contact options available to you. Visualize the way you'll use each one. Whittle down your list to the best ones.

Pick contact methods that you will use and respond to, as well as methods that are the most convenient for your customers. Then start listing at least three or four different ways for interested people to contact you.

Day 23
Don't Bore People to Tears

I don't know how many promotion packages and brochures I've read through while having to fight off yawns and wandering thoughts. In fact, I keep some of the more mundane marketing pieces I've collected in a drawer near my bed, in case I get a bad case of insomnia. All it takes is a couple of paragraphs of this dreck and I'm sleeping like a baby.

Let this be a lesson to you. When you communicate with people in an effort to motivate them to spend money on you, you must be passionate, energetic, interesting, captivating and intriguing. So don't bore people to tears with humdrum marketing materials.

For starters, don't be afraid to make a bold statement. Give your fliers, ads and brochures large, attention-getting headlines. A live sound technician I know once used the headline "Reliable Soundman Available for Your Next Gig" in his ad. That's a pleasant approach, I suppose. But how much more attention would his ad have gotten if it read "Tired of Your Music Sounding Like CRAP?"

Don't be afraid to be bold.

Also, don't shy away from using humor. I realize that a lot of marketing gurus caution to use humor sparingly, but I encourage you to go for it if you feel it's right for your identity. Life is too short to take yourself too seriously.

Please note that you should take your talent, product and/or service seriously, but a lighthearted attitude – used in the right measure – can work wonders in grabbing attention and holding interest.

For example, a video production company once offered to feature bands on its local music TV show by proclaiming, "Are you ready to expose yourself in front of thousands of people?" That's funny (it's a flasher reference, in case you missed it), and it works for that particular promotion.

I also recall a band that used a print ad to advertise that it was breaking up and bidding farewell to its fans. However, the bottom half of the ad listed a series of upcoming "reunion" shows and announced the release of a debut CD. Again, the ad used humor that was appropriate for the fun image of the band.

Also, make your marketing words sparkle with action verbs. And put prospective customers right in the middle of things by writing in the present tense. To clarify, here are good and bad examples:

BAD: "The person who uses my service will get a professional juggler who has much experience providing entertainment for corporate functions."

Are you still awake? That description reads like a resume. And it probably doesn't come with the smelling

salts needed to keep readers conscious. Here's a better pitch:

GOOD: "Don't get stuck with a lame stand-up comic or karaoke singer again! When you're ready for something truly different to spice up your next sales meeting, Frank the Juggler is your answer. Sorry, no chain saws or bowling balls ... but wait till you see the flying cat trick. Call for a FREE videotape and Juggling Fun Pack today!"

Be lively, be upbeat, be specific – make your words jump like electricity off the page! Your potential customers will enjoy it. And you'll enjoy the rewards of getting extra business ... without putting anyone to sleep.

Commitment statement:

"My creative marketing efforts work best when my promotional pieces and personal approach are lively, intriguing, active and exciting. I am not timid about being bold or using humor (when appropriate) to grab the attention of potential customers."

Today's Action Step

I hate to do this to you. Having read today's lesson, I know you're fired up about creating exciting marketing materials. So when I ask you to look over some of the promotional tools you're currently using, it may be downright depressing when you realize how much they fall short. But it is necessary to drag yourself through this process.

By now you have most certainly updated your brochures, fliers, product sheets and sales letters so that they focus on customer benefits – not on you and your accomplishments. And you've beefed up these materials with testimonials from reliable third-party sources.

That means your promotional success tools are stronger and more effective. But do they sparkle with personality and originality? Or do they just lie there on the page?

Start writing down notes on how you can add extra sizzle. And answer these questions:

- Do you have an intriguing story to tell?

- Is there a funny angle or headline you can use?

- Can a current event be tied into your particular talent offering?

- Is there an eye-catching photo or illustration available to use?

Stretch your mind. Expand the normal boundaries of what you consider to be appropriate "selling."

I warned you early on that I would insist that you use your creativity when it comes to marketing your artistic talents. Now is the time to put that creativity to use.

Happy brainstorming. And whatever you do, do it with pizzazz!

Day 24

Understand the Value of Your Past Customers

Many creative people correctly place a great deal of emphasis on generating a steady stream of new customers. That's a smart move. The only way to grow is to consistently develop relationships with an expanding number of fans.

The only thing is, it's easy to get caught in the trap of focusing on new business so much that you forget about the good people who've purchased something from you in the past. And when you consider how much time, energy and money it takes to create new business (inspiring someone to buy your creative product, come to your live show, sample your service), it becomes clear: Catering to people who have patronized you in the past makes good economic sense.

People who have already done business with you not only know about you, they have also demonstrated their faith in your talents by spending money on you. It's far easier and less costly to bring your message back to these people for a second (or third or fifth) sale than it is to try and convert a completely new prospect.

That doesn't mean you should abandon your efforts to bring new customers into the fold. But don't get so

wrapped up in it (and other distractions) that you overlook the people who've already proven their income-producing interest.

I know of many companies that have sizable customer mailing lists to which they haven't sent anything in the past year. Yet, during those same 12 months they've run thousands of dollars worth of advertising to generate new customers. This is preposterous!

The first thing you must do to make the most of past customers is to set up a system that captures the contact information of every paying customer. Your system can include order forms on your web site, mail-in forms from a catalog or forms you ask people to fill out at craft shows, etc. (You should also get permission to follow up with anyone who expresses even a passing interest in your work.) Whatever you do, don't let people show an obvious interest in your talents and then let them slip away without capturing a way to get back in touch with them.

A prime example to illustrate the value of past customers comes from the mail order industry. When a catalog company rents a "cold" list of prospects (people who've never done business with the catalog), it's considered a success if 1 to 2 percent of the list responds with an order.

However, when a company mails the same catalog to its "house" list (people who've purchased in the past or requested to get the catalog), the response can be 5 percent or higher. Which do you think is more profitable?

Even if you don't publish a catalog, make sure you find some way to communicate with your past customers – via mail, phone, e-mail, fax, whatever – on a regular basis. Doing so will ensure you get the best of both worlds: revenue from both new and old customers.

Commitment statement:

"While I must always seek out new sources of business, I am also committed to regularly staying in contact with – and making new offers to – the people who have purchased my creative product or service in the past. This way, I get income from both new and old customers alike."

Today's Action Step

I'm sure you're eager to get out your journal and write another list, right? You do want to make progress with your creative goals, don't you? Good, I knew you did.

Even before you read today's lesson, I'm sure you were already aware of the importance of staying in touch with past customers. But you probably hadn't formulated a definite plan of action to do so. Today, that will change.

No one knows your niche of the creative market better than you. So let me ask you: What are some of the best ways to keep in touch with your previous customers?

First, consider the various methods of communication:

- First-class letter
- Post card
- Self-mailing brochure
- E-mail newsletter
- Personal e-mail note
- Phone call
- Fax
- Face-to-face visit

Then consider the messages you might send:

- New product or service announcement
- Special discount offer
- Welcome-back invitation
- Anniversary or holiday offer
- Invitation-only party

These are just some suggestions. Please add some of your own ideas to the list. Next, match up specific offers with specific means of contact, based on what's most appropriate for your audience. Then plan these activities into your marketing calendar.

Your past customers hold the greatest potential for current and future profits. Don't ignore them.

Day 25

Upsell Your Customers So They Get More of What You Offer

In yesterday's lesson we talked about the importance of returning to your past customers with new offers. So what about your current customers? As you might have guessed, there are also strategies you need to employ with the people who are spending money on you right now.

But don't wait until some randomly chosen date in the future to make another pitch to them. Make an irresistible offer right now, while they're expressing a serious interest in your talents.

There are a number of effective ways to upsell your customers and inspire additional sales. The trick is to dangle more alluring benefits in front of your clients while their interest levels are running high. This isn't being manipulative, by the way. You're simply giving people an opportunity to get even more of the great creative skills you have to offer.

For example, let's say someone buys a piece of your handmade jewelry by mail. Of course, the "average" creative marketer would stick the item in a package and

send it off. Period. Maybe later, he or she might send a flier that lists other merchandise for sale. But why wait?

The smart creative person sends the jewelry piece along with a flier listing all other available products – your handmade bracelets, earrings, necklaces, broaches, even jewelry by other artisans.

In addition, the package would also include a certificate stating something along the lines of: "Thanks for your order. To show my appreciation, please use this 10%-off coupon on your next purchase of our handmade jewelry. As an added bonus, order within the next 30 days and take an entire 20% off. It's my way of saying thanks for supporting my craft."

A private music teacher might have a number of different levels of instruction, from beginner to advanced. I know a teacher who offers discount incentives to students who sign up for the more advanced levels ahead of time. Even if they don't commit right away, when customers finish the first level, they are prime candidates to be approached with a special offer to sign up for the next level.

Regardless of what creative vocation you choose, sell a line of related products or a service that lends itself to repeat business. Supply something else your customers need. There's hardly an artistic business niche that wouldn't profit by offering add-on features.

For instance, most of the recording studios in my hometown offer CD duplication, in addition to multi-track recording services. When a studio's musical customers are finished recording their songs, they're ready to make multiple copies of them on CD. So it

makes sense for a studio to also offer this service. CD duplication is the next logical step after the recording process. And the smart studio owner is right there offering to upsell his or her customers to the next sales level.

Another example of this concept in action is the series of art books and videos put out by the late Bob Ross, a renowned artist known for his skills of teaching students his landscape painting techniques.

Did Ross put out one instruction book and video and then stop? Hardly. Go to any fully stocked art store and you'll most likely see a display featuring an entire series of Bob Ross landscape painting resources.

Aspiring artists who buy one kit are prime candidates to return and purchase more Bob Ross instructional books and tapes. It's a natural process that makes his customers continually happy. It also made Bob Ross a successful and prosperous artist.

So what needs do your customers have after doing business with you the first time? What's the next logical step they'll take after getting the benefit of your initial product or service? Look back at your customer profile and the reasons they buy from you and start figuring this out – because a whole new stream of revenue is waiting to be tapped.

Commitment statement:

"My relationship with my customers does not end after the first or second sale. Each sale creates an opportunity to upgrade

and make another. All I need to do is discover the next logical step in the process, and then offer that benefit promptly."

Today's Action Step

One of the most effective ways to increase revenue from your current customer base is "bundling." The concept behind bundling is simple. But it can only work if you have at least three or more different (but related) products or services to offer.

With bundling, you give your customers a choice. They can either purchase one item from you at a time at the regular price. Or they can buy an entire package of items at a reduced price. Not everyone will choose the package deal, but offering it will lead to bigger sales from your diehard fans and customers.

I did this with my line of info-products for aspiring songwriters and musicians. I offered a music-marketing manual, two audiotapes, seven special reports, a press kit critique service and more. My customers had the choice of purchasing the individual titles at fair rates ... or they could buy the entire "Guerrilla Music Marketing Power Course" for close to half off the regular price. With this bundle of titles, my customers saved money and got a lot more of the help they needed; I brought in more cash flow and added to my profit. It was a wonderful trade off.

Answer these questions:

- What creative products do you offer that could be bundled?

- Do you provide a variety of services (or could you widen the variety of what you offer)?

- Can you think of other products you can create or resell that would be of interest to your current customers?

Write down a plan of action. What types of items would you like to offer? How could you bundle them (and at what price) so they're the most advantageous to you and your customers? Think about how you can put the power of bundling to work for you.

Day 26

Be Persistent at Reaching Your Creative Goals

By now you've got a head full of ideas, a journal filled with success-inducing activities and more enthusiasm than should be allowed by law. Before long, you'll be fully immersed in the pursuit of your creative goals. By all means, enjoy this exciting stage of your personal development.

But what happens when certain aspects turn sour? Or when people you thought you could trust let you down? Or when things progress at a much slower rate than you expected? When negative things happen, you'll be tempted to feel like a failure – like your well-intentioned efforts have been wasted. You may even think of giving up.

The truth is, times of despair often bring us the most strength. I know with my own history, low points were often followed by explosive bursts of achievement. It's not because I love being under pressure or that I ignore the bad stuff that happens. On the contrary, I examine it in detail – which, frankly, can lead to frustration and even mild depression.

The key is to gather strength after you've allowed yourself to feel some pain – and then use that pain to

motivate yourself to do things better in the future ... starting right now.

I've come to the conclusion that there are certain traits that allow most successful people to get over the slumps. And, undoubtedly, we all encounter these potholes along the path to pursuing worthy goals. Most importantly, the right mental attitude will make the ride a lot less bumpy.

Marsha Sinetar wrote *Do What You Love, the Money Will Follow*, a good book with a fabulous title. The philosophy contained in that title has been adopted by many prosperous people in creative businesses – from fashion designers and filmmakers to songwriters and performance artists.

In fact, the thrust of this book can be summed up by paraphrasing Sinetar's sentiment this way: *Do what you love, because the money will indeed follow – if you really want it bad enough!*

This philosophy also implies rather bluntly that you may be doing what you love for a while before the money and recognition catch up. While I've given you hordes of ideas and proven strategies for speeding up the process, chances are you'll still have to deal with the lull between doing creative things and getting a substantial payoff.

That's where persistence will help you immensely.

Whenever tough times are upon you, give yourself a break. Feel free to take a few hours or a day off to regain your center (if you have that luxury – if not, at least take a few minutes).

After this cooling off time, look back on the notes you wrote to yourself regarding your desire – the reasons *why* you chose this area of creativity. Focus on the original vision you had for serving others and enjoying the process. Then get busy making a list of ways you can make things better and avoid slumps and mistakes in the future.

That's what persistence is all about: feeling the bumps and then going to work to make your success vehicle more sturdy and ready to take the next bump that comes along.

Commitment statement:

"There will be bumps along the road to my success. But those bumps will be easier to take if I remain true to my vision and persistent in my efforts to reach my creative goals."

Today's Action Step

You know that, even though you are filled with positive expectations, you must brace yourself for the disappointments you will encounter along your creative journey. But what happens when you do encounter frustration? Will you respond by just winging it? No. You'll be prepared for speed bumps because right now you're going to create a slump-busting game plan.

First, make a list of things you'll do to give yourself a break when times get tough. Please note, though, that you're not running from or avoiding your problems;

you're just giving yourself a chance to regain a clear head.

Here are some of the ways I refresh my soul:

- Pay a visit to a favorite bookstore or art supply retailer. It's easy for me to get lost in an atmosphere of creative ideas.

- Go to a museum or art exhibit.

- Call or visit a friend or relative I haven't talked with in a long time.

- Take a long walk through a nearby park.

- Exercise.

They're not fancy, but these activities do serve to cleanse the mental palate. Once you're sufficiently cleansed, it will be time to get back in the saddle. Therefore, next I want you to make a list of things that will help you feel better about yourself and get you pumped up again about your creative mission.

Here are a few things I recommend:

- Pull out your file of testimonials and customer compliments. (You did start one, didn't you?) Read through some of the letters. Reminding myself of the good I've done for others always helps me get back on target.

- Grab a book or tape from your personal development library. Over the years I've built up quite a collection of books and audiocassettes on self-improvement, positive thinking, marketing, publicity, creativity, sales and more. These resources are always there when I need a boost.

- Take the first simple step toward a new project. Even if I'm still shaken from a recent setback, getting busy with something new helps me to regain my bearings.

Use some of these examples or make your own list of ways to get away or things to do to get back on track. That way, when you do hit obstacles, they won't be nearly as hard to overcome.

Only two more days to go.

Day 27

Keep Failure in Proper Perspective

No one likes to fail.

Most people avoid it at all costs and feel like rejects when they become its victim. In fact, the fear of failure keeps the majority of the population from going after truly worthy goals.

This is especially true of creative people. After all, why should artists, writers and performers take the risk of failing, when they can more easily play it safe and keep going through the comfortable routines that have satisfied their basic needs for so many years?

The point that all these fearful people keep missing is the fact that failure has as much to do with achievement as success does. People who succeed have tried more things and have put themselves on the line more times than the average Joe or Jane. By taking reasonable chances, action-oriented people open themselves up to the possibility of stumbling and not getting everything right – in essence, they almost assure themselves of failure. And that's exactly as it should be.

How many stories have you heard of pop music superstars who originally played for 10 years and got

turned down by 12 record labels before getting signed? Or writers who crafted in obscurity for decades before their first blockbuster novel?

In the sports world, consider the most successful baseball players. If a player maintains a consistent .300 batting average, he is usually considered to be one of the better hitters in the league. But in reality, that means on average he doesn't get a hit 70 percent of the time he goes to the plate. Seven out of 10 times he picks up a bat he fails. He has to put himself on the line and fail that often just to get enough successful at-bats to become one of the best among his peers.

The same goes for beginning guitar players. How many missed frets and sour notes did it take Eric Clapton to get good enough to impress others and make money doing what he loves? How many lousy auditions or sloppy scenes did Tom Hanks have to go through before reaching the point where he was respected within the movie industry?

Within every success story you can bet there lies a hundred failures.

Keep this in mind while pursuing your creative dreams. Take chances, learn from your mistakes and watch your progress unfold before your eyes.

Commitment statement:

"I know that failure is a natural part of achievement. The most successful people in the world have failed the most number of times. By putting myself on the line and actively pursuing my

goals, I will occasionally stumble. But I'll get right back up on my feet, shake off the dust and continue a steady path down the road to my authentic life."

Today's Action Step

Get out that journal. It should be close by, since you've been using it so often in recent weeks.

List some of the failures in your life – especially the failures associated with your creative pursuits. Begin with the most recent and work your way back.

Don't feel bad if you come up with a lot of them. That just means you're very ambitious. Can't think of any failures? Come on, dig a little deeper. Think of the times you took risks or occasions when you felt embarrassed.

Once you've got a good list, go through each failure one by one and ask yourself what you learned from the experience. Write down your thoughts and answer these questions:

- How did going through each failure help you along the path to where you are now?

- What positive things can you say about each negative experience?

- How many of your perceived failures turned out to be blessings in disguise?

- Isn't it possible that all of your failures are blessings?

- How different would your outlook be if you used the word "blessing" or "project" or "challenge" instead of "failure" or "problem"?

Examine your attitude toward your failures. You're far better off seeing them as the productive lessons that they are.

Day 28

Develop a Healthy Set of Success Standards

Welcome to the final day of the four-week course section of *Unleash the Artist Within*! I'd like to end by examining what I feel is one of the most important mental outlooks you'll need as you move forward from here.

Most of us want to be successful. We strive to better ourselves and we aspire to reach a level in our creative career that's beyond our present position. And that's what growing and improving is all about: stretching our human abilities.

But how do we know when we get there? What measuring stick do we use to indicate that we've arrived?

Sure, financial goals are great. As we discussed earlier, it's important to set up a level of income that you expectantly journey toward. And one way you know you've arrived is reaching those important dollar figures.

But, let's face it, money is only part of the reward. While bringing home a decent paycheck has been covered in this course, it's just as much of a priority for you to reel in those dollars doing something you love –

which, in this case, just happens to involve putting your creative skills to great use.

Therefore, you have to develop standards of achievement beyond the bottom line, beyond simply the number of digits in your bank account. Plus, as you know, it may take a bit of time and a lot of persistence on your part to get to the place where you're earning the dollars and getting the recognition you want.

So what are you supposed to do in the meantime to know and feel you are successful?

First, ask yourself this question: What has to happen in order for me to feel I'm succeeding at my chosen creative niche? And answer it honestly. Write down your thoughts and read the next few paragraphs. Then we'll come back to your answers for some closer evaluation.

I've posed this same question to a few people in recent years. Let me share with you the answers provided by Bill and Mary, two people whose standards are quite different.

Bill is an energetic and funny actor who believes he won't be truly successful until he gets cast as a regular character in a sitcom on a major network. To him, that's the real measure of accomplishment – along with the fame and fortune that go with it.

Unfortunately, Bill has been quite frustrated lately. He's been getting lots of roles with regional theatre productions, and even makes decent extra money doing local commercials and corporate instructional videos. Many of Bill's actor friends are envious of his local success. But Bill is nowhere near landing that sitcom acting job, and he's feeling more and more like a failure.

Mary, a folk singer, is also ambitious. But she has a different set of standards. While she strives for higher levels of music business achievement, she maintains a modest appreciation for being able to actively participate in the field she loves.

She has a real sense of gratitude that the world (along with her own instincts and desires) has given her the gift of music. To feel successful, Mary says she just has to be able to continue playing her guitar, writing songs and performing for small groups of people on a regular basis.

That's it. As long as she's able to strum her instrument and perform original music, she's filled with a sense of purpose and accomplishment. And it appears she meets those qualifications at least a couple of times every week. To use a corny phrase, Mary is quite the happy camper.

So again, I ask you: What has to happen in order for you to feel you're succeeding at your chosen creative niche?

Have you created a set of standards that allows you to feel constantly fulfilled, or have you set yourself up to always feel that you're not good enough because you don't measure up?

Do you need to have a million fans or customers to feel like you've made it? Do you have to have $50,000 in the bank to be worthy?

Do you need to have the same square footage or same size display ad as the competition to feel you're successful? Do your standards even need to be based on tangible, material items in the first place?

To give you an idea of a different approach to measuring success, I'll show you the nine standards by which I measure my own progression in life:

I am successful if I am:

1) Creating pleasure for myself and others

2) Learning, growing and stretching myself

3) Driven by a burning desire to accomplish something specific

4) Believing in myself and my abilities

5) Coming up with plans and strategies to get what I want out of life

6) Acting on my ideas and going for it

7) Fine-tuning and adjusting my actions to get better results

8) Allowing myself to fail (and learn from my actions)

9) Having fun and living in the present moment

Remember, when you feel successful in your creative pursuits, it fills you with the energy needed to push ahead and get more of what you want. Without that warm glow of accomplishment, the trip will be all uphill. So give yourself an empowering list of success standards to strive for.

Commitment statement:

"While I want to be ambitious and stretch myself, I must also give myself a solid set of standards by which to measure my success. Not all success is based on material and financial

acquisitions. In essence, I am successful as long as I am in hot pursuit of the creative things I love doing."

Today's Action Step

Since it's our last day, we'll keep things simple with our final Action Step. Think about my "thought for the day" and examine the nine success standard examples I've given you.

Next, create your own list of things that have to happen in order for you to feel successful and fulfilled. You're welcome to use some of my suggestions, but please feel free to create a list that works for your individual needs. Your list doesn't have to include nine things – one or two would be fine also.

Bottom line: Give yourself a set of standards by which you measure your success. And make sure it's a list that will inspire you to stretch while making you feel good about yourself and your creative pursuits every day.

Final Thoughts on the Four-Week Workshop

Congratulations on completing the four-week *Unleash the Artist Within* workshop! You've just done what the majority of aspiring creative people never get around to: investing consistent time, action and mental energy into their creative goals.

You've spent the last 28 days in a row – nearly an entire month – focusing your attention on what matters most to you and your creative passions. By doing so you have set in motion a new pattern of commitment and action that is propelling you on an invigorating journey.

However, heed this warning: It's easy to buy a book, read a few chapters over the course of an evening or a couple days ... and after that let it sit on a coffee table or bookshelf and gather dust. The same thing can be said about taking a class ... and then letting your attention wander on to other matters.

Don't let your momentum slow down. You may have completed the course, but your passion for creativity is alive and well and eager to be exposed. Make sure you continue to feed this desire on a daily basis.

Regularly review the lessons and affirmations. You can even start all over again with Day 1 and review the course again – if not next month, do it during a month in the near future. Regardless of what method you use to stay focused, you must exert some form of action toward your creative goals on a regular basis ... and preferably every day.

Congratulations again on completing the workshop. I sincerely hope that the best of everything comes your way. You deserve it!

–Bob Baker

Section Two

Ignite Your Creative Passion

This section features a collection of articles and tips that were written to inspire creative people to make the most of their talents. Use these ideas and success stories to further ingrain the important concepts we covered in the four-week workshop. Draw on them to promote your talents, attract more fans and paying customers, get more exposure, boost your creative energies and more.

19 Ways to Promote and Sell Your Creativity

Whether you have a passion for art, writing, music, photography or poetry, you quite likely feel that you're filled with unbounded creativity. Why, then, does all that creativity seem to dry up when it comes to marketing your special talents? Why must you continue to work in obscurity? If this is your frustration, it's time for a change. Use some of the following 19 real-life techniques to help you launch a new promotional campaign.

1. Start Somewhere, Anywhere – Do Something Now

Never let a lack of money, knowledge or connections stop you from at least taking the first small steps toward getting recognition and exposure for your talents.

Los Angeles artist Kristine Kadlec could have waited until a respected art gallery invited her to exhibit her work. But she was ready to publicly display her work right away. That's why she pitched a Borders bookstore in the area with an idea. That effort led to her first solo exhibit, "Artistic Recycling with Paper Weave Collage," at the store.

Just because her artwork wasn't being shown at a traditional venue, that didn't mean Kadlec would treat it lightly. She mailed 500 invitations, sent press releases to local media, promoted the exhibit online through art-related discussion forums, contacted area arts organizations and more. "This is my first solo exhibit and I'm planning to get as much promotional mileage as I can," she said.

What can you do right now to promote and expose your talents?

2. Use Low-Cost, High-Impact Post Cards

Bob Westerberg is a copywriter who specializes in technology subjects. For many years, one of his most potent sales tools has been a monthly post card mailer he refers to as "the world's smallest newsletter." Every post card features a collection of light-hearted facts and trivia, along with a plug for his copywriting services. Since the idea is so novel, and since post cards are noticed and read so easily when they arrive in the mail, Westerberg's mailing pieces are widely enjoyed by the people on his mailing list. He reports that this single technique generates about $25,000 a year in freelance writing assignments.

How might you use post cards to get more attention?

3. Describe What You Do in 10 Words or Less

When you get an editor, director, gallery manager or other important contact on the phone, he or she may very well ask, "So what exactly is it that you do?" How will

you respond? By hem hawing around about how unique your craft is and how you "hate labels"? Don't get caught in this trap.

You should be able to define your creative skills in 10 words or less. Why? Two reasons:

1. So you can quickly communicate your creative niche to media folks, industry people and potential customers

2. So you can use it as a gauge by which to focus all of your performances, titles, artwork, photos, ads and more around a consistent theme. People (including you) shouldn't be confused about what they get from you.

Examples: If you're in a band, use a phrase such as "We play blues rock with a touch of funk." If you're a writer, say "I specialize in how-to articles about sales and marketing." An artist might explain "I do black and white spot art for newspapers and magazines." A photographer might say "I specialize in spontaneous slice of life photos."

Whatever you do, make sure you can communicate it easily and quickly.

4. Do It Yourself

Don't wait to be "discovered" or for your lucky break to come along. Instead, start making things happen for yourself now.

Musician Lance King performs in a band that plays melodic hard rock music. King had big aspirations but he didn't want to wait around for an elusive major

recording contract. So he started releasing his own CDs and investigating the European market, where music from America is often in demand. He established a distribution network and has sold more than 15,000 copies of his band's CDs – all by taking his career into his own hands.

How can you take control of your future?

5. Combine Your Efforts with Other Creative People

There is power in numbers. Instead of thinking about being in competition with other creative people, start brainstorming on ways you can combine your marketing muscle with theirs.

Every year graphic designer Jeanine Colini teams up with a printer and either an artist or photographer to create a promotional year-at-a-glance calendar. All three parties donate their services and each gives the calendars away to hundreds of clients and prospects. By taking this three-way promotional approach, Colini reaches far more potential customers than she would on her own.

Start thinking about how you might cross-promote with other creative people.

6. Give Away Promotional Samplers

During an outdoor concert, the Rick Recht Band had full-length CDs available for sale during and after the show. No surprise there. But the band members also repeatedly announced that they had a limited number of

sampler tapes featuring three new songs that anyone could have for free.

Handing out free samples is a great way to create a promotional buzz. What could you give away to help promote yourself? A short excerpt from your novel? Inexpensive prints of some of your best artwork? Free public performances of your theatre troupe's current production? Think about it.

7. Turn a Perceived Weakness Into a Strength

A group of Nashville painters, sculptors and photographers – who all happened to be visually impaired in some manner – pooled their resources and presented "Art of the Eye: An Art Exhibition on Vision." Proceeds from the event went to a charity that helps people with sight challenges. A group of local optometrists sponsored the exhibit.

Do you have a perceived shortcoming – physical, mental, financial or otherwise? If so, look for opportunities to turn your situation into an advantage. If the aforementioned artists can, so can you.

8. Choose an Attention-Getting Title

Whether your creation is a novel, film, theatre production, music CD, book of poetry or art exhibit, give it a name that will create some curiosity and excitement.

When comedic actress Andrea Martin put together a one-woman show, she called it *Nude Nude Totally Nude*. From what I understand, the reference related more to her baring her soul than her flesh. But you must admit,

it's an eye-catching title. Of course, something this outrageous might not work for a conservative art form such as a symphony orchestra (although *Brahms in the Buff* has a nice ring to it), but there are still appropriate titles that could easily be used to draw attention to any event, performance or other new creation.

9. Self-Syndicate Your Own Column

Do you create a product or service that appeals to a group of people who can be reached through specialized publications around the world? If so, could details about your craft be conveyed through informational articles that you write yourself? For instance, let's say you put on workshops for actors. You could write a series of articles featuring tips for aspiring thespians and offer them to arts-related newspapers in your region.

Jeffrey Lant has self-published 10 books on various aspects of marketing. He offers a series of columns filled with money-making tips to any publication that wants to run them. He gives them away free to the publications as long as they include a plug at the end letting readers know how to contact Lant and get on his mailing list. His columns run in more than 200 newspapers and online publications, and they bring in thousands of sales leads. Many of these inquiring readers end up buying Lant's books.

10. Understand How People Benefit From Your Talents

It's not enough to just create your art, writing or performance and throw it out into the world. You must know why people are attracted to what you do. What physical and emotional payoff do your fans experience when they enjoy your form of creativity?

Kelly Borsheim, founder of Lumina Candles, understands this concept as she asks other artists, "What are you really selling – a thing or a lifestyle? Why would someone want what you have to offer? I am constantly thinking about which candles I want to make – and which I don't. I consider whether or not the candle fits my theme or philosophy. Is the product consistent with why customers do business with me?"

You'd be wise to ask yourself similar questions about how your fans benefit from your talents.

11. Create Take-One Boxes

Keep your eye out for small cardboard boxes you can recycle into "take one" containers. Print small hand-out-sized fliers that promote your talents or upcoming event. Place these in the boxes, which should be covered with artwork and text that says something along the lines of: "Do You Like (fill in the blank with a reference to your type of talent)? Take one of these." Then approach owners of establishments where your target audience hangs out and ask if you can place these unique boxes at their locations. Chances are, you'll be the only ingenious person in town doing this.

12. Offer a Tongue-in-Cheek Report or Survey

Take a poll of your peers, interview people on the street or just act as if you have ... it doesn't matter. This isn't scientific research; it's a fun way to hook the media into covering you. For example, you might announce the results of a survey titled "The Top Ten Reasons Rock Music Fans Believe Pro Wrestling Is So Popular" or "What 12 Toledo Poets Think of Punk-Rock Song Lyrics."

If it's funny and timely enough, many of the newspapers, magazines and Internet sources you contact will at least mention it, if not run the entire thing – while plugging the source: you and your creative affiliation. Also include this survey in a mailing to your fans.

13. Diversify and Expand

North Carolina artist Bob Timberlake first made a splash years ago with his paintings that depict rural life. Next, he persuaded a publisher to put out a series of books featuring his work. Additionally, Timberlake opened his own gallery and created an array of products that bear his unique painting style (post cards, furniture, neckties, plates, fabric and more).

I did this very thing with my own creative pursuits. In 1987, after years of playing music and writing prose on my own, I started my own newspaper in St. Louis, Missouri. For 10 years, *Spotlight* magazine was the established source for local music and entertainment news in town.

In 1990 I started a small mail order catalog of music business books put out by other publishers. Through

these efforts, in 1992 I met a publisher who put out my first book, *101 Ways to Make Money in the Music Business*.

The following year, I started self-publishing a series of audiotapes, reports and manuals on how to succeed in the music business. Over the years I've also seriously dabbled in acting, painting, doing stand-up comedy and more – which later inspired me to also offer *Quick Tips for Creative People*, a newsletter to help creative people of all kinds promote and sell their talents.

How might you expand and diversify what you're currently doing?

14. Connect with One Customer or Creative Contact at a Time

You don't have to market to millions of people and sell $2 million worth of your craft to be successful. Commit to working at the grassroots level, connecting with one new customer or artistic supporter at a time. At first, you'll have 10 contacts. Then 100, then 500, and eventually over 1,000 and more. Take the approach of slowly but surely building up your notoriety.

15. Use Testimonials and Positive Review Quotes

Don't just use your press clippings and comments from satisfied customers to impress mom and dad. Positive quotes from third-party sources add lots of clout toward your efforts to get press, exposure, paid work and more.

And don't wait for these glowing comments to come to you. Ask radio, newspaper and other industry people you know for a line you can use in your media kit.

16. Ask Politely but Firmly for Action

Whether your goal is to get a published piece of writing, a paid graphic design job, permission to submit a creative proposal or whatever, always make sure you ASK for what you want. And do it pleasantly and confidently.

17. Have an Attitude/Take a Stand

Creative people who try to be all things to all people usually come up short when promoting themselves. The most successful artists know who they are, know what they stand for and aren't afraid of alienating some segments of the population when expressing themselves. Sure, you may rub some people the wrong way. But the fans who do identify with you will support you all the way.

18. Write Down a Plan of Action

While you want to be flexible enough to take advantage of promotional possibilities that spring up, nothing beats having a solid plan of action. And writing down those plans gives them substance. Ask yourself the following questions:

- What specific message do I want to get across to customers and industry people?

- What are the best methods to get that idea across?

- What creative, effective tactic should I pursue first to promote myself?

- What should I do next?

Write down your answers to these questions and develop a more refined plan based on them. Then take the first step and get busy. The plan is always subject to change, but simply having one in the first place really gets you moving toward your goals.

19. Follow Up on Everything

This should be a no-brainer, but you'd be surprised how many people pay lip service to the concept of follow-through and still overlook it. The idea here is simple: If you tell someone you're going to send a package or a fax, for example ... make sure you do it! Once the package or fax is sent, follow up with a phone call to make sure the person received it and ask if there's anything else the person needs. Wait a couple of weeks (or however long is appropriate for the situation) and call again to get the status of the review, feature story, paid job or whatever it is you're after.

Don't expect other people or the whims of fate to take care of your career. Grabbing the reins and staying on top of your promotional activities will virtually guarantee that good things will happen to you.

15 Insights to Help You Uncover, Develop and Stimulate Your Creativity

Sometimes you need a new perspective (or even a mental kick in the pants) to shift your thoughts and actions into gear. Use the ideas in this section to jump-start your gray matter and boost your creative pursuits.

1. Affirm That You Are Already Filled with Creative Potential

I hear a lot of people say, "Artists and writers are so creative, but not me. I just don't have that kind of mind or ability." People who say such things live with the mistaken belief that they were born without the creativity gene or an artistic chromosome. Somehow, nature or God or whatever passed them over when giving out creativity certificates.

Even artists themselves fall into this trap. "I really want to make more of my talents, but I just don't have what it takes," some writers, artists and performers say. "I don't have the money it would take to promote myself, plus I have no idea where to even start."

Sorry, but I don't buy these common excuses. All human beings have the ability to think more effectively

and creativity. In fact, without even knowing you, I'll bet you're a lot more mentally resourceful than you think.

Whether it was repairing your car when you didn't have exactly the right part, or figuring out a way to get Christmas presents for your kids when you barely had money, or finding a solution to a customer complaint at your day job ... you've had plenty of situations in your life when you had to think (and act) creatively to get things done.

So don't try pulling that "I'm just not creative" line with me. I know better. Stop thinking of yourself as deficient and lacking in this area of your ability. You are perfectly creative just as you are.

Sure, there may be people who exercise and stretch their brains more often than you. Therefore, they may appear to have some sort of upper hand in the creativity game. But the truth is, they have the same tool to work with as you do: a hunk of gray matter between their ears. And just like any muscle, the more you use it, the stronger it gets.

So no more excuses. Let the creativity games begin!

2. Become Successful This Very Minute

Back when I was a junior or senior in high school, a friend let me borrow a book called *Your Erroneous Zones* by Dr. Wayne Dyer. The book dealt with simple ways to enjoy life and take charge of unhealthy behavior patterns. It was the first book I'd ever read in the "self-help" category, and it did have a positive impact on my life. Since then, I've read or listened to many of Dyer's books

and audio programs (and I encourage you to do the same).

There are a couple of principles among Dyer's teachings that will help drive home the point I'd like to make here. First, a person's self-worth is not determined by external factors. What you think of yourself has absolutely nothing to do with someone else's opinion of you or the achievement of some material goal.

While confidence and mechanical skills are qualities that develop through experience, your feeling of self-worth has only one origin: your thoughts and your decision to feel that way about yourself. And that is something you can give to yourself right this minute. There are no other prerequisites. You are a worthy person merely because you believe it is so.

Dyer's second principle concerns success. He contends that success is not a destination that you reach. Success is something that exists inside of you and that you bring to everything you do. It's not something you go and get; it's something you make a decision to be and demonstrate through your actions.

Chad Taylor, guitarist for the band Live, once told a writer for *Bam* magazine that he developed his passion for playing music in the midst of negative people who told him that he couldn't make a living playing music – that he couldn't be successful because the odds were against him.

"And I just thought, 'That's gotta be baloney,'" Taylor explained. "The day I decided not to go to college and to be a songwriter for the rest of my life instead, that was

the day I became successful. It didn't take three or four million records to make me successful."

Marketing consultant Dan Kennedy refers to this attitude as "self-appointment." Instead of waiting for approval, permission, a degree, a promotion or reaching some predetermined level, truly successful creative people decide that they are already worthy of success and start acting like it.

"Most people wait around for someone else to recognize them, to give them permission to be successful," Kennedy writes in his *Ultimate No B.S. Business Book*. "You don't need anybody's permission to be successful. If you wait for 'the establishment' in any given field to grant you permission, you'll wait a long, long time. And remember, success is never an accident, no matter how it appears to outsiders."

I often meet creative people and ask what they do. The answers frequently sound like this:

- "Well, I'm hoping to make it in journalism."
- "I'd like to become a hit songwriter."
- "I'm trying to find out if I have half a chance of succeeding as a graphic designer."

These folks are obviously looking for some measuring stick or nod of approval to justify their artistic aspirations. But their ultimate symbol of worthiness won't come from an external source. There will be no white knight to crown them with a seal of approval.

The only person who can give you permission to succeed is YOU! And when you finally realize that and give yourself the gift of self-appointment, you'll answer

my simple question by saying, "I am a journalist" or "I'm a country music songwriter" or "I'm a freelance graphic designer."

Sometimes people ask me, "Bob, how did you become an author and authority on self-promotion for artists?" My answer: "I decided to be one." Of course, I had to back up that self-appointment with writing skills and the ability to give people the information and inspiration they want. But no one had to give me the green light or grant me admission to this field. I made a decision to do this regardless of external feedback and have been loving it ever since.

Take a moment to honestly answer these questions:

- How are you currently relying on external factors to feed your sense of self-worth?

- What positive things are others telling you about your creative goals?

- What negative things are others telling you about your creative goals?

- How do you respond to bad reviews or rejection?

- Do you describe your creative goals in tentative "maybe" terms or as an activity that's fully in progress?

- Do you believe success is something you acquire or a quality you bring with you and display?

- What do you need in order to feel worthy and successful this very minute?

Now it's your turn to use your mind, make some decisions and give yourself a much-deserved promotion.

3. Build a Personal Development Library

What started as a few self-help books and audiotapes several years ago has evolved into a small personal development library at my house. I didn't plan it that way. It just crept up on me. One time a friend was over and started browsing through my bookcases.

"If you really read all these books, you'd be the leader of the free world," he said. Well, I'm not a world leader (nor do I want to become one), but it made me realize just how overwhelming my collection had become.

The thing is, I have not sat down and read most of these books from cover to cover. I don't know if I have a short attention span or just get distracted easily, but I tend to read in short bursts. A few chapters here, a couple of pertinent sections there.

If I'm having a challenge in the area of sales, I pick out a marketing book and look for ideas. When I want to launch a new PR campaign, I scour books on publicity. When I'm feeling stressed or mentally out of balance, I turn to something that caters to the calming, spiritual side of life. The same thing goes for books I own on creative thinking, the workings of the brain, health, finance, writing and more.

Having a self-development library puts instant inspiration at your fingertips whenever you need it. I suggest that you build your own, while also exposing yourself temporarily to books from the public library. Doing so will stimulate your mind and cause your brain to generate its own set of ideas and philosophies on whatever subject it is you're reading about.

4. It Has to Happen Clearly In Your Mind First

Some time ago, I renewed my interest in acrylic painting (a hobby I've enjoyed on and off since the 7th grade). For inspiration, I checked out some painting books from the local library. One of them was an old, tattered book by Lenore Sherman called *Creative Painting*.

Most of this short book, as you'd expect, was made up of pictures showing the various stages of Sherman's paintings. There was very little text. But among the sparse verbiage, I came across this gem:

"We live in a world formed from ideas. Look about you wherever you happen to be and you will see the many results of man's accomplishments – tables, chairs, clocks, houses, etc. Remember that before any of these came into the visible or material world, they were first ideas in the mind.

"Painting is the visible expression of ideas held by the artist. It is first a mental activity and then a physical expression. Therefore, if an artist has only a vague idea of his subject and a hazy notion as to the technique of painting it, then the painting will show this uncertainty."

Those words make a simple but powerful statement that can be equally applied to art, business and life.

So, let me ask you: What kind of pictures are you painting in your mind? How clear are your mental goals for the future? Are they gray and fuzzy around the edges? Or are they big, bold, sharp and vibrant? Your thoughts must become focused in your mind before they can ever materialize in the real world.

To me, that's one of the most appealing things about creative fields (painting, writing, performing, playing music) – the process of turning a good, clear idea into its inevitable physical form. Once you have that tangible version of your creation, you can share it with others and reap the benefits of personal satisfaction, recognition and extra income. But before that can happen, the mental seeds must be planted and sowed diligently.

5. Break Out of Habit Patterns

If you always do the same things in the same ways, you run the risk of stunting your creative thinking abilities. The solution: Deliberately program changes into your daily life. Make a list of things you do by habit and, one by one, consciously try to change them for a day, a week or a month. Try these:

- Take a different route to work.
- Change your sleeping hours.
- Listen to a different radio station.
- Read a different newspaper or magazine.
- Take a bath instead of a shower.

And while you're at it … Brush your teeth in the kitchen ... Randomly pick an aisle at the library, close your eyes, blindly choose a book and read it ... If you always drink Diet Coke, order lemonade ... If you always watch NBC for the nightly new, switch over to CBS or ABC.

In other words, shake up your routine and you'll improve the flexibility of your mind.

6. Stimulate Your Subconscious Activity

In his book, *Maximum Achievement,* Brian Tracy writes about what he calls the Law of Subconscious Activity. According to Tracy, this law states that "any idea or thought that you accept as true in your conscious mind will be accepted without question by your subconscious mind. Your subconscious will immediately begin working to bring it into reality."

Tracy asserts that when you begin to believe that something is possible, your subconscious mind starts broadcasting mental energies that eventually attract people and circumstances that are in harmony with your new beliefs.

In my own life, I've experienced this principle at work countless times. When I was 19, my main goal in life was to become a guitar player/vocalist in a successful local rock band. But I was only jamming in basement bands at the time, dreaming of the day I'd play the St. Louis area nightclub circuit.

There was a club called Stages just across the river in Illinois. To me, playing this spacious facility was the ultimate symbol of "making it" locally. But I was nowhere near being in a position to perform there. I could only sit in the audience and watch the top bands play ... while imagining myself doing the same thing. And did I ever imagine! I didn't realize it at the time, but I was visualizing my goals – running over and over in my mind what it would be like to play on that stage.

Shortly after I turned 21, I joined my first working club band. We started playing at a growing number of popular nightspots in the area. About a year and a half

later – when I was 22 – I got word that we had finally been booked to play Stages. I remember the joy of pulling up to the club and entering through the backstage band entrance for the first time. It was really exciting.

When our performance started, I recall having a strange sense of confidence and familiarity. Even though I'd never actually stood and performed on that stage, I'd been there dozens of times in my mind. It was just a matter of acting out what I'd imagined so many times before. And I believe it was those powerful visualizations that led to the achievement of my music goals.

Everyone may not have access to the same state-of-the-art computer equipment or deep-pockets financing sources. But everyone on the planet – including you – has direct access to the most powerful tool of all: your own mind. Use it!

7. Set an Idea Quota

Here's a great idea I got from reading Michael Michalko's book, *Thinkertoys*. Challenge your brain to go to work on a current problem by coming up with a minimum of five new ways to handle the problem every day for one week straight.

At first the ideas will come slowly, but once you open the mental gates, they'll start to flow. One idea will lead to another and so on. Many of these solutions will be unworkable, no doubt. But the more possibilities you come up with, the better the chances that a couple of them will be true winners.

8. Don't Overlook Raw Ideas from Left Field

Creative thinking expert Edward de Bono believes that "One of the weakest aspects of creativity is the 'harvesting' of ideas." In *Six Thinking Hats*, one of many books by de Bono, he recalls some of the creative sessions he's attended during which a lot of good ideas emerged. However, after the sessions, many of those good ideas went unrecognized because they weren't developed enough.

"We tend to look for the final clever solution. We ignore all else," de Bono writes. "Apart from this clever solution, there may be some new concept directions. There may be half-formed ideas that are not yet usable. New principles may have emerged even though they are not yet clothed in practical garments."

Creative oversights are commonplace in the corporate world. A group of suit-wearing, tie-strangled executives sits in a room with no windows to conduct an emergency brainstorming session. Ideas are evaluated and shot down as quickly as they are generated. The same problems creep up as the same old, predictable and lackluster solutions emerge.

But you're in a creative field, right? Your mind is uninhibited. Ideas flow from you like water off the back of a sea otter. Now take off the rose-colored glasses and look closer. Are you really making the most of all of your ideas? Do you nurture them and give your more outlandish concepts a chance to grow their own legs and mature?

What about your idea to send homemade fish pizzas to every local media critic who covers your field? How

about the crazy concept you came up with to display your artwork on the back of a pickup truck as you drove it around town? And what became of your notion to publish a collection of poetry about Elvis?

Sure, these ideas are silly. But might some of them have merit? Can any of them be reshaped or refined into something that really could work? As I've stated before, you won't develop fresh approaches if you play it safe and stick with the routine. Challenge yourself! A world of opportunity awaits you.

9. Trust Your Inner Creative Ability

There are times when the river of creative ideas flows freely. Especially in no-pressure situations when you're in a humorous and playful mood, you can do no wrong. Ideas spring forth like a fountain, most of them immediately useful and met with approval.

Of course, there are other times when the well runs dry. The door slams shut. The closed sign is indefinitely staring you in the face. When this happens, it's easy to convince yourself that your muse has gone out of business, never to return again.

But instead of giving up, realize that those are the best times to put a little old-fashioned faith to work for you. You absolutely must trust that your inner ability to find solutions is firmly intact – and that it's just going to take a little time for the answer to appear.

Your first instinct may be to think that there are no ideas to remedy this current situation, that's it's a no-winner, no matter what. Great. Acknowledge those

thoughts, and then gently move them aside. It's time to put on your detective cap and play a little mental game to get you out of this rut.

Imagine that there is not only one, but many – perhaps dozens – of easy and effective solutions to your challenge, many of which are in the room with you now or just a phone call away. Your job is simply to uncover them.

The key to making this work is in the knowing. Don't hope that solutions exist, or say you'll try to find them for a few minutes to see if it works. You positively must know that good answers are waiting to be discovered, and you must have total trust in your ability to find them.

Look through books and magazines in your office, make a few calls and run your problem by people not involved with it, go to a bookstore or the library – all the while continuing your search for the clues that you know are there.

This happened to me a few years ago as I was preparing to go to press with the music magazine I used to publish. Everything for the current issue was ready to go, but I had been going through a slim financial period and was behind on paying my printing bills.

The printer, understandably, wanted the few thousand dollars I owed for the previous two issues before he would print another one. But my bank account had nowhere near that amount. What to do?

I immediately started brainstorming on how I could raise or borrow the money. I made lots of calls and racked my brain out, but no solution was in sight. How

was I going to pay the printer? I was getting frustrated and uptight. Then I decided to relax and let the answer present itself to me in its own way.

And it did.

Once I saw the light, I made a call to a printing company I had used in the past. With the other company, I needed less than $2,000 to get the one issue printed. Going this route, I got the issue out on time and was able to bill my advertisers, which allowed me to eventually get caught up with paying the first printer.

It seems like such a simple solution now. But the doubt and anxiety I put myself through shut down my ability to find sensible options. I only focused on one aspect of the problem, instead of expanding my options.

Trusting your creative instincts pays off – whether you're making a business decision, writing a play or searching for the right chord pattern in a new song.

Even if you still come up blank after an afternoon or entire week of "knowing and trusting," take a break and do something else, still having the inner confidence that you're on the verge of a discovery. When you least expect it, the first answer will appear. Then others. And when the final solution is chosen, you won't be shocked at all that you eventually found it. Because you knew it was there all along.

10. Start a Creativity Tickler File

Collect and store ideas like a pack rat. Keep a container (a coffee can, shoe box, desk drawer, whatever) and start collecting interesting quotes, designs, thoughts,

questions, cartoons, pictures, doodles and more. When you're looking for new ideas, shake up the container and pull out two or more items at random. Then see if they somehow trigger a thought that might lead to a new idea concerning your current project.

11. Balance the Creative Process with the Product

If you create with a certain product – or end result – in mind, you have a direction, a goal, a destination you are trying to reach. On the other hand, if you create with a focus on process, you can go anywhere. You have more freedom, which means your possibilities are potentially endless.

In the book *Life, Paint and Passion* by Michell Cassou and Stewart Cubley, I found this excellent observation:

"In creative painting, the defining moment is when you face the fertile white void. Your openness and your courage to step into that void with the spirit of exploration are all that matter. The power of painting lies in the process itself, not in the resulting product."

Obviously, this passage encourages you to absorb yourself in the creative process without concern for the outcome. And yes, this seems to contradict a message I endorsed earlier: You must have a clear picture in your mind of what you want before you take action. As with all areas of life, a balanced approach is best.

The older I get – and the more I read and write self-development material – the more I understand that few nuggets of useful information are universal. For example,

let's use the topic of being assertive. If you're not assertive enough in your career pursuits, you'll most likely move ahead too slowly.

On the other hand, if you take the assertive attitude too far, you may rub people the wrong way and go nowhere even faster. The best way to be assertive is to be pleasantly persistent. In other words, finding the right balance is essential.

Lately, I've been referring to this approach to life and work as the "yin and yang of abundant living." In some situations, approach A works best; in other situations, the opposite method is preferred. And such is the case with our dilemma of creative product vs. creative process.

My advice is to spend time on both angles: process *and* product. Neither approach is more worthy than the other. They each have their place and should both be engaged at the appropriate times.

For instance, if we stay with the subject of painting, there are times when the idea for a picture seems to appear in your mind. When you paint, you are simply reproducing what you see in your head. Also, if someone pays you to create a work in a certain style, it's your job to provide the vision that the customer wants. With these examples, the creative product takes center stage.

However, there is also a lot to be said for painting and experimenting with mediums and techniques – without any concern for what the final image will look like. Not only is making art in this manner freeing and spiritually therapeutic, but it often leads to happy "accidents" that latter find their way into future works.

This philosophy can be applied to any worthy endeavor – writing, performing, running a small business. If you concentrate exclusively on the predictable, end result, you can't expect fresh and innovative ideas to surface. So be sure you regularly make time to engage in your craft without regard to the product – and lose yourself in the thrill of simply being and creating.

13. Use Your Spiritual Energy to Enhance Your Creativity

"Energy is in all things in our universe ... If it is everywhere, then it is also within us," writes Dr. Wayne Dyer in his book *Manifest Your Destiny*. He goes on to explain that we have access to energy because we are energy. "We can use this universal energy to bring to us objects of our desire, because the same energy that is in what we desire is also in us and vice versa," he says. "It becomes a matter of alignment and will that allows us to tap into this force."

I don't know what your spiritual leanings are, but I've always considered myself a pretty open-minded person. While I'm receptive to new ideas, the analytical side of my brain proceeds cautiously before accepting metaphysical beliefs as fact. Still, I find a lot of comfort in Dyer's writings. There are two reasons I'm particularly attracted to his words of wisdom:

- The idea of a universal energy that connects everything puts our world in a healthy context. The things we want and the accomplishments that have eluded us are not so distant and foreign after

all. We are made of the same stuff and vibrate with the same energy as the things and ideas for which we strive. Thinking of the world in those terms makes it easier to keep pursuing the things we want in life.

- Even if you don't truly believe that you can tap into a universal energy stream, you can still visualize that as the natural state of things and benefit from it. For example, when trying to relax, people often imagine in their mind's eye that they are in a favorite peaceful place. Even though they don't believe they're really at that serene location, pretending that they are provides a stimulus to reach a desired state.

If my second point is true, couldn't someone also benefit from visualizing that the universe is comprised of a giant energy field? And that every human had the ability to tap into it and use it to better herself or himself for the good of all concerned? Certainly! Your brain would shift into a mode of harmony and abundant thinking.

Even if you're not "logically" sold on your ability to tap into this energy field, try using it as a mental technique to help you be more creative and attract the qualities and rewards you deserve. It's worked for me. And if it turns out there really is a universal energy source, so much the better.

14. Keep an Idea Journal

Don't expect your memory alone to capture and retain all of your great ideas. Buy a notebook or journal

and make it the place where all of your new thoughts get written down. Not only does this create a reference to which you can refer, but the physical, sensory act of writing down an idea serves to further ingrain the concept into your thinking patterns. And once you've created one, flip through your idea log often.

"To keep ideas coming for future paintings, I keep a book with me and scratch down ideas as they come," says Ann Weigel of Artistry by Ann. The ideas she captures range from thoughts on subject matter, lighting and method to design, coloring and impressions for different ways of looking at an object.

"When I start feeling like there are no new subjects or approaches to try, I look in my trusty book and find that there are ideas there that can be used, combined or separated."

15. Make a Creative Top-10 List

To best demonstrate this, let's say you're trying to brainstorm on ways to mount a successful crafts show. Take a piece of paper and write the numbers 1 through 10 down the left side. Now start listing key words and phrases that describe various aspects of a well-run crafts show.

You might include phrases such as "Good attendance," "Media coverage," "Door prizes," "Unique exhibitors" and so on. Write down these familiar terms up to number 8. For 9 and 10, list completely unrelated words such as "dog collar" and "baby shampoo."

Now randomly pick two of the numbers and see what kind of associations the word combinations conjure up. For instance, concentrating on "media coverage" and "unique exhibitors" might lead to an idea about pitching a story on the most attention-getting crafters to local newspapers. Or offering a free booth to a local media personality who paints for a hobby.

When the ideas run dry on this combination, pick two other numbers and see where they take you. Then move on to another combination.

The last two oddball phrases are there to jolt you out of your comfort zone. For example, how could you possibly come up with ideas based on "door prizes" and "baby shampoo"? Well, how about raffling off $50 gift certificates to a local toy store or hair salon? "Good attendance" and "dog collar" might lead to the concept of cross-promoting your show through unlikely places like pet stores.

You never know what ideas will pop up by mixing and matching various aspects of your challenge.

Now that you have these 15 insights, use them to uncover, develop and stimulate your creativity.

18 Low-Cost, High-Impact Ideas You Can Use to Market Your Creative Talents

I want to challenge you with this section. It's safe to assume that you acquired this book to get a few new ideas that might help you take your creative endeavors to a higher level. But you've done the same thing with books and magazines you've purchased before. What I want you to do with this resource is actually use it. Don't just think about these ideas and then set them aside. This must become a truly interactive document for you to get the most out of it.

Therefore, as you read this section, highlight the parts that excite you, write in the margins and refer to it when you're in a rut and in need of fresh ideas. Don't treat this book like a sacred artifact. Get close to it, get it dirty and – most importantly – really use the most appropriate tips in this section to promote your talents as a writer, artist, performer or other creative person.

1. Write a Letter to the Editor

Respond to a creative topic related to what you do that's covered in your local newspaper or even a national magazine, and work in a subtle mention of your product,

service or skill. As long as you have an informative, insightful comment and don't over hype yourself, chances are good your letter will end up in print – and give you extra exposure for free.

2. Write Your Own Specialty Column

Even better than a one-time letter to the editor is your own column – either in print or online. If you're a graphic designer, offer the local business magazine a column on how to create brochures and other materials that bring in customers. If you're a yoga instructor, approach a health and fitness publication with the idea for a series of articles on using your mind and body to relieve stress. You may have to offer these articles for free, but doing so will establish you as an expert in the community.

3. Offer Informational Seminars or Workshops

If you're not frightened by the thought of public speaking, you should be presenting informative workshops. They have proven to be very effective for reeling in new customers. Like the newspaper column idea mentioned before, seminars are often presented free of charge. But you'll usually generate enough paying customers through free workshops to make them worthwhile.

Give your workshop a catchy title. For instance, a crafts store might present "12 Simple Ways to Decorate Your Home with Handmade Crafts." Of course, during the seminar you must provide truly useful information,

including a compelling reason to use your product or service to meet attendees' needs.

4. Produce a Customer-Generating Freebie

This idea alone can be one of your most powerful marketing tools. Create a simple, low-cost report or tip sheet that supplies useful information of interest to your ideal customer. For example, I once wrote a report called "12 Ways to Survive the Holidays Without Adding Inches to Your Waistline" as a seasonal promotion for a personal fitness trainer. Using the free report as a hook, she generated tons of inquiries, some free media exposure and $2,200 worth of paying clients in one month.

Once you create a report that's right for you, promote it in all your ads and publicity efforts (the media loves to plug these free items). Then follow up with everyone who requests the freebie.

5. Present an Award or Hold a Contest

In the same way that surveys, free reports and seminars can lead to public awareness, so can awards and contests. They can either be serious (an Entrepreneur of the Year Award, a Poetry Contest) or more light-hearted (Stupid Carpenter Tricks, the World's Largest Twister Game). One hot sauce maker sponsors an annual Chili Cook-off that gets a mountain of press. The best awards and contests will tie in nicely with your creative product or service. Find one that works for you.

6. Use the Internet to Market Yourself

No doubt about it, computers and the Internet are the wave of the present. If you're not yet online, it's about time you got wired and got connected. Here are a few easy ways to use the Internet to market your creative passions:

- Set up a simple web site using one of the many free hosting sites on the Internet.

- Add your e-mail and web site address to all your business cards, brochures, letterheads and other marketing materials.

- Encourage people to use e-mail to ask questions, get on your mailing list and place orders.

- Compile a list of customers' and potential clients' e-mail addresses and request permission to send them regular offers – with e-mail, there are no printing or postage costs.

- Participate in online forums and chat areas that pertain to your industry; you'll be surprised by how many new contacts you'll make.

- Post useful bits of information to newsgroups and ask people interested in your business to contact you.

- Surf the Internet, visit pertinent web sites and contact the webmasters of the best sites.

- Join specialized mailing lists that send you correspondence from people involved in your industry.

7. Uncover the Best News Hooks

Announcing the hiring of a new hair stylist at your salon won't get you very far with the media. However, hiring a former centerfold or the police chief's sister might catch the attention of a fashion editor. Why? Because is has a news hook that makes it stand out.

So what's your news hook? Does your company name have a significant meaning? Have any of your employees or customers won awards, done brave deeds or accomplished anything noteworthy (they don't have to be work-related)? Have any of your customers used one of your products in an unusual way (a way that won't land them a spot on *Springer*, that is)? Always be on the lookout for fresh news hooks surrounding your creative niche and, when you uncover a good one, talk it up to the media.

8. Publish a Newsletter

When it comes to marketing options, this should be a no-brainer. Most business people know that newsletters can be an effective way to stay in touch with current, past and potential customers. Newsletters give useful information and remind people of what you have to offer. Yet few creative people actually put this powerful tool to good use.

Printed newsletters take time and effort to produce, so it's easy to keep putting them off. Meanwhile, hundreds (or thousands) of potential clients may go a half a year or more without seeing anything about you and your creative offers. *Time-saving idea*: Newsletters

don't have to be slick 8- or 16-page productions. A simple two-sided, 8.5" x 11" self-mailer will do the trick just fine.

E-mail newsletters, however, are relatively easy to write and send – plus there are no printing and postage costs. So there are no excuses here. Make sure to regularly invite people to subscribe to your free e-mail newsletter. Then send useful messages to them often. There are many free services available online to help you manage e-mail lists. The two I recommend are Topica.com and YahooGroups.com.

9. Make the Most of Post Card Promotions

When most creative people think of direct mail, they immediately conjure up images of catalogs, fancy brochures, sales letters, postage-paid response cards, order forms and more. While these are all worthy tools, don't overlook what I consider to be the secret workhorse of direct mail: the simple post card.

No folding, stuffing or licking to worry about. Just fill both sides of a basic post card-size mailer with brief, snappy, benefit-rich descriptions and offers. Then pop them in the mail – for a lot less money. Post cards are great for just about anything: art exhibits, performance dates, grand openings, new product announcements, new CD releases and more. They do work.

10. Offer Your Creative Product or Service Free to Radio Disc Jockeys

The weight-loss company Nutri-System had tremendous success some years back when it offered

radio disc jockeys around the country free enrollment in its service. On-air jocks who had success with the program (and many did) were so pleased with the results that they consequently talked it up during their shifts. This led to a lot of free (or at least low-cost) exposure for the company. Would your product or service lend itself to this radio-marketing tactic?

11. Use a Strong Headline in Every Ad, Brochure or News Release

Simply listing all the talents you offer is great, but research shows that bold, attention-getting headlines (with more details following in the smaller-sized body copy) pull the most response. In addition to using a bold headline, it's important to craft the right one – meaning a headline that will reel in a substantial number of sales leads and orders.

For instance, a violin teacher might come up with a headline for an ad that reads "Quality Violin Instruction Since 1989." That's great, but unless she's trying to illicit more yawns than paying students, she'd be wise to try a more benefit-oriented angle. A better headline might be "Play the Violin in Three Hours or Less – Guaranteed." That's a lot stronger. If she wanted to turn some heads, she might also try "We Turn Nerds Into Superstars!" The rest of the ad would then explain the benefits in more detail. The same idea can be applied to your brochures, fliers, press releases and more.

12. Always Include Complete Contact Info

No matter how interested in your product or service you think people receiving your marketing materials might be, they'll never be as interested as you are. They'll get sloppy and misplace things. Free samples will become separated from business cards; press releases will wander away from accompanying photos, etc.

Therefore, it's your job to put your contact information on every piece of paper that leaves your office (this goes for faxes and e-mail, too). This contact info may include your address, phone, fax, pager, e-mail and web site. Include as many as will help you generate more revenue with your creativity.

13. Seek Out Lucrative Cross Promotions

I once knew a pizza parlor owner who did business three doors down from a videotape rental store. She was frustrated that her restaurant wasn't selling more pizzas. Also, she regularly griped about how the video store had so much more foot traffic than she did. The sad thing is, it never occurred to her to approach the video storeowner with a win-win, cross-promotion idea.

What if the two businesses exchanged a stack of discount coupon fliers? The video store would give a pizza coupon to all its customers. The pizza place would hand out a video rental coupon to its patrons. Both of them could benefit greatly from this simple concept. I suggested this idea to her, but she never did pursue it. Are you making a similar mistake with the promotion of your talents?

14. Send Thank-You Notes

This is a simple act, but it really does make a difference. After a writer does a story on you or a disc jockey interviews you on the air, send a quick note of thanks. Do the same after productive meetings (yes, they really do happen) or a big sale to one of your customers.

Small acts of random kindness do make an impression on the people receiving them. And it just may cause them to have a cozier attitude toward you the next time you approach them for more business or a simple favor.

15. Communicate (at Times) with Customers When You're Not Trying to Sell Something

You probably won't be surprised to hear this, but success in the creativity business has as much to do with the quality of your relationships as it does with the quality of your artistic product or service. The idea here is to make friends with people who are in a real position to do business with you and help you.

But a friendship is a two-way transaction. If you communicate with someone only when you need something from him or her, the relationship is not the healthiest it can be. That's why you should get in the habit of calling, mailing, faxing and e-mailing your creative contacts occasionally when you're not trying to sell them something. Call and ask how a recent holiday went, to wish them a happy birthday, to pass along some information you came across that might interest them, etc.

You should always have a specific objective any time you communicate with someone – it just doesn't always have to be self-serving.

16. Specialize – Don't Try to Be All Things to All People

When you think of Stephen King, what image comes to mind? Unless you've been living in a cave, you think of a prolific writer who creates novels filled with terror and suspense. But what if Mr. King also put out books on gardening, cooking and personal finance? How successful would he be then?

Surely, King could write such books if he put his mind to it. So why doesn't he? Because he has a niche that people clearly identify him with. Therefore, he succeeds on a much higher level by specializing instead of trying to please everyone. Learn from this lesson. Have a clear idea of how you best serve your clients with your creative talents. Then focus, focus, focus ... while avoiding the temptation to spread yourself too thin.

17. Write Like You Talk

Even though I should be used to it by now, it still astounds me when I read letters that contain phrases such as "per our conversation on the 14th" or "in reference to the aforementioned item." Who are these people trying to impress, their college English professor? One thing's for sure: They certainly aren't making an impact with customers.

The same goes for dry terms that creep into countless brochures and other sales materials. Stop trying to sound so official with your prose, and start writing like you talk! Instead of writing "Our customers' satisfaction level is at the forefront of our service commitment," why not just write, "Your satisfaction is our top priority – we guarantee it!" If you wouldn't say it that way to a customer's face, don't write it that way in your sales literature.

18. Make It Easy to Remember You

Create a short, easy-to-remember name for your company, web site or catalog. There's a moving/hauling business not far from my house called Two Men and a Truck. You can't get more basic than that, but what a great name. There can be no doubt as to what service this firm provides. Who would you rather hire? Two Men and a Truck or Smith Hauling Services?

9 Steps to Unleashing Your Creative Brain Power

No matter what business you run or what line of creative work you're in, you need to generate new and innovative ideas – and lots of them – to stay on top. When you're able to develop fresh approaches to sales, marketing your craft or performance (or even aspects of your personal life), your rewards are more satisfying. You feel productive and effective. You get more respect and have a lot more fun.

So if creative thinking carries so many benefits, why do so many artists and supposedly "creative" people avoid it like a root canal?

Actually, there are a lot of good reasons. When you come up with new ideas, you have to take risks. What will other people think? What if the idea gets shot down? Plus, it's never been done that way around here before, so why rock the boat?

My advice to you is this: Get over it!

Progress and growth don't occur without some amount of risk taking. And they certainly won't happen in today's world without a steady stream of fresh ideas in both your business and personal life. With that in mind,

here are the nine essential steps you need to take to free your brain and unleash the creative power that lies between your ears.

1. Define Your Focus

Before you can embark on a creative thinking journey, it helps to know what your ultimate goal is. The best way to get focused is to define your particular problem or challenge in the form of a specific question.

"How can I sell more of my art?" might seem like a noble goal, but the question is too broad and fuzzy. However, "How can I increase the sales of my collage prints by 25% next quarter?" is a very precise question. Asking the right question is the first step to getting a lot of great answers.

2. Make Like a Sponge

Once you define your focus, you need to soak up as many details concerning the subject as possible. It's good to know the background and current status of the situation before you can improve upon it. For instance, it would help to know how many collage prints you sold last quarter, which customers bought the majority of them, what methods were used to make the sales, etc.

It's very important to note that you're simply absorbing information at this stage. You're under no obligation to begin generating ideas here. You're simply warming up the engines of your mind, preparing for the turbo-charge that's about to come.

3. Take Off the Black Robe

As you're about to start your brainstorming session – whether it's by yourself or with a group – it's absolutely essential to emphasize this point: **During the idea generation stage, everyone must suspend judgment.**

There will be a proper time and place to evaluate and rate your ideas later. Right now, your purpose is to crank out the seeds of unlimited possibilities. If you start critiquing at this stage, you'll stifle the creative flow. So don't censor yourself or make any negative comments to others regarding their ideas.

The goal of creative brainstorming is to open the floodgates of the mind. If you slow down the flow by trying to evaluate during this stage, the ideas will likely dry up altogether. And that's not what you want. So take off your judge's robe and resist the urge to criticize.

4. SOB x FUN = TCI

Don't be frightened by this mathematical-looking formula. It's simply a fun way to describe the most effective method of idea generation. It may look like a scientific equation ... but, believe me, this ain't rocket science. Here's how the formula breaks down.

SOB stands for Stimulation of Brain. Creativity doesn't happen in a vacuum. While nature has equipped you with a powerful and marvelous brain, you are still a human being. As a human, you are a creature of habit. Your mind recognizes and creates patterns in your life to help you get through your day more effectively. How

else would you be able to brush your teeth, tie your shoes or drive a car without a lot of conscious thought?

This fabulous aspect of your brain, though, has some drawbacks. When it comes to creativity, your mind has a tendency to fall back on routines. You'll generally come up with ideas the same way you've always come up with them – often with the same lackluster results.

Take heed, my creative friend. That's where the SOB part of the equation comes into play (no, that doesn't mean you curse when you can't think of anything new). You have to jar your brain out of its comfortable patterns by purposely bringing in fresh stimuli. Books, magazines, toys, games, catalogs – anything that can trigger associations and get the mental juices flowing.

It's also good to involve all of the senses by stimulating them with sights, sounds, zesty flavors, smells and textures. Some of these stimuli should be related to the subject (meaning, your well-defined question), while much of it should be unrelated. Holding your brainstorming session in an unusual and relaxed environment will also make a dramatic difference. Getting out of the familiar setting of your regular work area will contribute to the thinking skills of all involved.

FUN refers to Fantastic Unbridled Nuttiness, or more simply put, "fun." Nothing loosens up the brain waves like a good dose of humor and play. Try this sometime: Sit down with a bunch of grim-faced, suit-wearing executives and attempt to "seriously" generate ideas. I've done it, and I'm here to tell you that this method guarantees the onset of mental constipation.

Doug Hall, a former Proctor & Gamble marketing guy and author of the book *Jump Start Your Brain*, regularly brings groups of corporate types to his Eureka! Mansion for brainstorming retreats. Much of the first day is purposely spent playing with Nerf Blaster toy guns, racing on Hall's go-cart track, cranking up a CD of TV show theme songs and other zaniness.

Hall is also known for bringing back the granddad of all novelty items: the whoopee cushion. He is convinced that having a loose, fun attitude is essential to generating blockbuster concepts. I wholeheartedly agree!

TCI stands for Truly Creative Ideas. These are the ideas that really make a difference. Some are so different they can be mind-boggling. Others are so simple that it takes the idea-generation process to reveal them. Truly Creative Ideas are the ones that get your blood pumping – or at least make you think, "A-ha!" When you get them, you know you've discovered something special. If you're not getting them now, you're most likely skipping one or more of these nine steps to creative thinking.

Here is the idea generation formula again:

Stimulation of Brain (SOB)

x Fantastic Unbridled Nuttiness (FUN)

= Truly Creative Ideas (TCI)

In other words, bombard your senses with both familiar and unfamiliar objects and environments, and have lots of fun doing it. If you really commit to this formula, the truly innovative ideas will indeed flow.

5. Go for Quantity of Ideas

Coming up with creative concepts should not be a stressful, frustrating affair. But it does take mental energy and focus. Some people are ready to call it quits after the first five or ten ideas are generated. Don't make this mistake. To uncover the truly amazing ideas (Doug Hall calls them "wicked good ideas"), you absolutely must crank out lots of them.

Sales people know this philosophy all too well. The more phone calls you make, the more appointments you set and the more sales you close. Think of it as a funnel. For every ten drops you pour into the top end, only one or two come out the bottom. But what potent drops they are! The same idea can be applied to creativity.

Also, since most people really enjoy themselves and have fun during brainstorming sessions (that is, if they're being done right), a fear comes over the group that maybe they're not "working" hard enough. So someone says, "Okay, we have enough possibilities here. Now let's get down to real business." *Beware*: If you're drawn into this line of reasoning, you're simply cheating yourself.

The more ideas you generate, the more thoughts you can spin off of them. So take as much time as you need for this stage. The right amount will depend on your particular challenge – a simple session might last only one hour, while a major brainstorming blast might continue for a full day or two.

Another thing to keep in mind is that, especially in group situations, it takes a while just to get everyone loosened up. Some of the best ideas will come later in the

process. Don't shut off the flow too early. And remember, quantity is king.

6. Take a Chill Pill

Once you've spent an adequate amount of time generating ideas, you need to get away from the subject and the process. Why? To give your brain a rest. And to get some distance between you and you're newly created ideas so that you'll be able to view them semi-objectively when you return to them.

"Learn to pause," wrote poet Doug King, "or nothing worthwhile will catch up to you."

Another important reason get away from the subject is to let your subconscious mind do some of the work during the chill-out period. Even though you may not be mentally focused on the topic, your brain will be percolating in the background. And this can lead to even more (and better) ideas. Many great discoveries have occurred when someone working on a problem was doing something else. For instance, Notre Dame football coach Knute Rockne came up with the idea for his famous "Four Horsemen" defense while watching a vaudeville chorus line.

Haven't you ever had the mental light bulb flash while taking a shower or driving in your car? It may have been hours or days since you last thought of the subject, but there it was: The right answer at an unexpected time.

Make sure and use this time off to clear your head – and don't be shocked if an amazingly good idea pops into your brain when you least expect it.

7. Evaluate and Rate Your Ideas

Now it's time to put on your evaluation hat. Go through the ideas and begin rating them. And ask a lot of questions:

- What is good about this idea?

- If it's a little far-fetched, is there something about it that can be salvaged or adapted?

- How can we make this idea even better?

- Can we combine this concept with another one here to come up with an even bigger winner?

Once you get your ideas down to a list of the best candidates, you must figure out how much implementing them will cost, how much time and effort will be involved, who will be responsible for what actions, etc. This is the time to rationalize, crunch numbers and think logically. In other words, this is where you judge your ideas.

I know I've stressed this before, but here it is again: You must wait till this seventh step to evaluate ideas. Do it sooner and you'll sabotage the process, with few good ideas on which to espouse your opinions. Then you'll complain, "See, I told you this creative thinking junk doesn't work." Save the judging for this step, where you can pick apart your ideas with wild abandon.

8. Refine Your Plan and Commit to It

Once you've narrowed down your ideas to the one or two very best ones, you'll need to write out a game plan. That will include a time line (what gets done when) and a

list of activities, job descriptions and responsibilities, resources you'll need and so on.

This is also the time you must commit to your ready-to-implement idea. Some people get squeamish when they get closer to setting a new concept in motion – especially if it's daring or a little off-the-wall. Make a decision and stick to it. If you've spent this much time nurturing your idea, you must be ready to back it up with your focused energies.

Now is not the time to be timid. Instead, jump in with both feet and splash a lot of water around. Sure, you could play it safe and go back to doing things the same, predictable way you've always done them. But where will that get you?

So refine the plan for that new idea of yours and make a firm commitment to follow through on it.

9. Take Action!

Your fabulous new idea must be exposed to the world. It must be given the chance to take root and grow. So put it into action now!

A lot of creative people stop short when they're on the brink of success with a new concept or plan. There are also many people (and I'm sure you know a few) who come up with wonderfully fresh ideas, only to let them sit in a notebook or basement and gather dust.

Don't let this be your fate. You were born with a gold mine between your ears. By defining your focus, soaking up details on the subject, suspending judgment, tickling your brain with outside stimuli, having a lot of fun and

generating tons of ideas ... you'll come up with quality solutions and innovative ways of tackling your craft. And by taking some time away, letting your subconscious mind percolate, rating your ideas and refining your plan of action ... you'll be on the verge of taking great, new strides in your business, personal and creative life.

There you have them: the nine basic steps to unleashing your creative brainpower. Now what will you do? I suggest you move ahead to the next logical step and take Nike's advice: Just do it!

(I'd like to express my appreciation for the work of Dr. Arthur Van Gundy, who wrote *Brain Boosters for Business Advantage* and many other creativity books, and Roger von Oech, author of *A Whack on the Side of the Head*. The writings of these creativity experts inspired some of the content of this chapter.)

Closing Thoughts

As a creative person, you no doubt experience a range of emotions. There are times you feel giddy with pleasure and times you feel frustrated from being stuck in a rut. You most likely have these same feelings toward your creative niche.

Sometimes you ride high with the pride of creative fulfillment and accomplishment. Other moments are filled with a sense of hopelessness as you spin your wheels and ask, "Why do I even bother pursuing this childish nonsense?"

Instead of being a victim of this emotional roller coaster, why not embrace it? Make it your ally, your friend, your greatest strength. How? By using each of these mental states to propel you forward.

Feelings of intense satisfaction act as the carrot – they lure you to greater heights and inspire you to expand your horizons.

Experiences of disappointment can and should become the stick – reminding you of the pain that awaits you if you choose not to exercise your creative longings. Instead of letting frustration have its way with you, vow

to move even more stridently toward the carrot ... closer to the pleasure and away from the pain.

This might sound like psycho babble, but I firmly believe your potential for success in any creative field lies in the attitude and enthusiasm you bring to it – as well as your ability to handle the ups and downs that await you.

As we discussed in an earlier section, success is not something you go and get, it's something you make a decision to be and demonstrate through your actions – regardless of your circumstances or what appears on your list of excuses.

In other words, success as an artist is something that you ARE.

I sincerely believe this book provides the tools you'll need to become a success in your chosen creative field. The only thing left is for you to put these ideas into action.

Starting now!

This Book Is Just One Part of an Ongoing Creative Journey

I hope that your decision to read this book marks the beginning of a long-term relationship between us. I'm confident that the principles and suggestions in this book will inspire you and help boost your mental outlook and self-promotion efforts to new levels.

To make sure these ideas stick, I encourage you to visit my web site at **PromoteYourCreativity.com**. There you'll find free articles and countless resources to help you get more exposure, attract more fans and sell more of your creative product or service.

While you're at the site, be sure to get your free subscription to my e-mail newsletter, called *Quick Tips for Creative People*. Once or twice a month, the e-zine delivers a dose of motivation and marketing tips for writers, artists, performers and anyone pursuing a creative passion.

I'd love to hear from you, especially if you have a career tip or strategy that I could share with the thousands of creative people who subscribe to my e-zine.

Do yourself a favor and pay a visit to **PromoteYourCreativity.com** the next time you're online. You'll be glad you did.

–Bob Baker